IMAGES
of Rail

RAILROADING
around HAZARD
and PERRY COUNTY

IMAGES

of Rail

RAILROADING
around HAZARD
and PERRY COUNTY

Martha Hall Quigley

Featuring the photographs of John G. Kinner

ARCADIA
PUBLISHING

Published by Arcadia Publishing
Charleston SC, Chicago IL, Portsmouth NH, San Francisco CA

Printed in the United States of America

Library of Congress Catalog Card Number: 2006922339

For all general information contact Arcadia Publishing at:
Telephone 843-853-2070
Fax 843-853-0044
E-mail sales@arcadiapublishing.com
For customer service and orders:
Toll-Free 1-888-313-2665

Visit us on the Internet at www.arcadiapublishing.com

The last remaining artifact of the Lexington and Eastern Railway, a maintenance-of-way car, resides in the Bobby Davis Museum and Park of Hazard and Perry County. The privilege of obtaining this valuable piece was made possible by a friend of the museum, Jim Strong. The author is grateful to him for this opportunity and for all of his other contributions.

CONTENTS

ACKNOWLEDGMENTS

Deepest appreciation goes to John Kinner's family for their generous donation of his collection to the museum; Mr. and Mrs. Lawrence O. Davis for creating the Bobby Davis Museum and Park; Mayor and Mrs. Bill Gorman for their constant help; the museum board of trustees for their excellent guidance; Betty Feagan for her tremendous assistance through the years; Barry Hall for his artistry in adapting the map of Hazard; and Bill McGraw for bringing so many facts into perspective. To everyone who assisted in this archival adventure, please accept my endless gratitude.

INTRODUCTION

In 1987, Lawrence Oren Davis, founder of the Hazard–Perry County Museum, later called the Bobby Davis Museum and Park of Hazard and Perry County, Inc., donated a set of 296 photographs to the museum. Beulah Cooksey Cornett gave them to him around 25 years before. No information accompanied the photographs except some descriptions by Mr. Davis. Several of the images were recognizable from books and postcards; still they were obscure, unidentified photographs.

Mrs. Cornett's daughter, Betty Cornett Feagan, visited the museum in 1988 and attributed the whole lot to her great-uncle, John G. Kinner. Less than a year later, Betty Feagan brought the remaining Kinner pictures from her mother's collection to the museum. The second set contained handwritten comments on the reverse and numbers that corresponded to the first set.

In 1989, contact was established with Mr. and Mrs. Everett Rice, relatives of John Kinner in Buchanan, Kentucky. They made available to the museum a third set of pictures and negatives that had actually belonged to John Kinner's daughter, Ruth Kinner Solter. This grouping contained duplicates belonging to the other collections. Notations by Kinner's family were found on these photographs relating their experiences in Hazard.

John G. Kinner was born in Boyd County, Kentucky, in 1879. In 1911, he was hired to photographically document the 1910 survey and the acquisition of the right-of-way for the North Fork extension of the Lexington and Eastern Railway Company (L&E). He continued as the official photographer during the construction of the railroad around Hazard, Kentucky. His photographs appeared in these books: *The Story of Hazard, Kentucky: The Pearl of the Mountains* (1913) by Louis Pilcher and *1911–1913: Years of Change* (1991), and Images of America: *Hazard, Perry County* (2000) both by Martha Hall Quigley.

The book *1911–1913: Years of Change* was published by the museum during the Kentucky Bicentennial, and many copies were lost in a museum fire in 1992. *Railroading around Hazard and Perry County* uses all of the pictures from *1911–1913: Years of Change* and others from the Bobby Davis Museum collection.

Kinner and his family lived in Camp 4, where a large number of his pictures were taken. His two daughters attended Hazard Baptist Institute (HBI). The most extraordinary image produced by John Kinner is a panorama of the town taken from across the river. Practice prints for this outstanding photograph were found in his negatives. It can be viewed at the Bobby Davis Museum and Park of Hazard and Perry County.

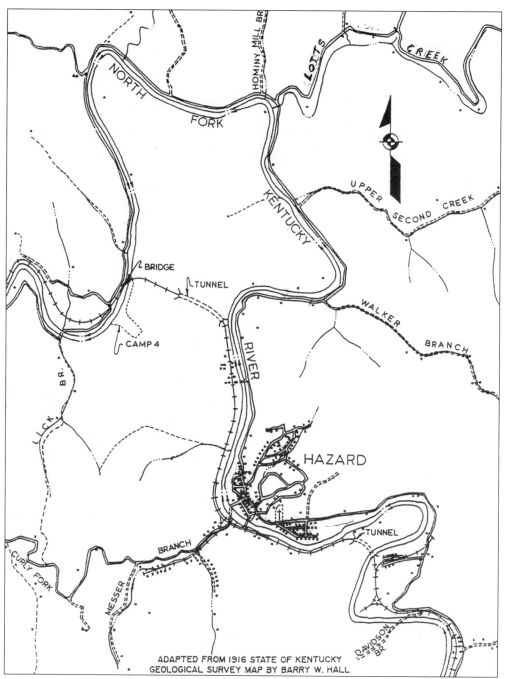

ADAPTED FROM 1916 STATE OF KENTUCKY
GEOLOGICAL SURVEY MAP BY BARRY W. HALL

Just a glance at this map that was adapted from a geographical survey in 1916 reveals how railroads and roads were plotted along waterways. On this map, man-made structures are indicated by dots. There are two tunnels on either side of Hazard. An engine turnaround is near Davidson Branch at the bottom. The high-density settlement in the same bend as the turnaround is Kentucky Jewell Coal Company in Lothair. (See page 92.)

One

JOHN G. KINNER

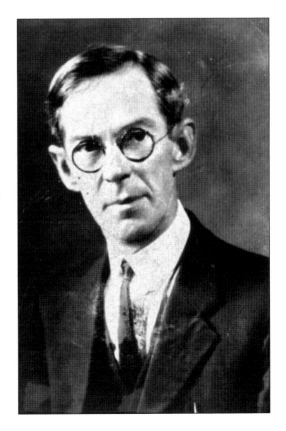

After John Kinner lived in Perry County for a year recording the process of building a railroad, he opened a photography business in Hazard. Kinner and his partner, V. N. Wooley, advertised that they were only a phone call away, and they were available to photograph customers in their homes. In an interview with the *Hazard Herald*, the first major newspaper in Hazard, he stated his belief that photography is a science and maintained that his photographs would endure with clarity for 100 years. His images in this book are now 91 to 95 years old. John Kinner performed a tremendous service for historians by writing descriptions on the reverse of most of his pictures. A large portion of the information for this book came from Kinner himself.

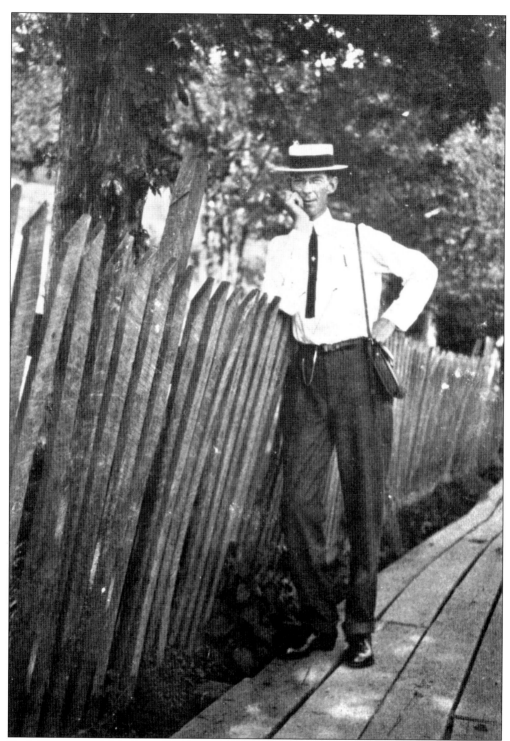

Ruth Kinner used John's camera to take a picture of him standing by a fence on Broadway. According to Louis Pilcher, author of *The Story of Hazard, Kentucky: The Pearl of the Mountains,* John Kinner, the photographer, did not like to see his own image in print.

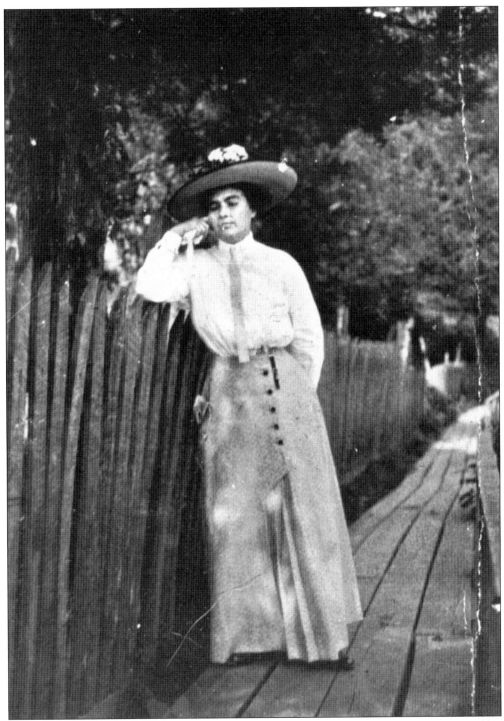

This is John Kinner's wife, Ruth Rankin, also from Boyd County. This pairing of Kinner and his wife is very typical of John Kinner's creative style. In the photographs that Kinner took for the railroad, his artistry comes out in unusual and surprising posing of human subjects. He described his own style as "carefully careless."

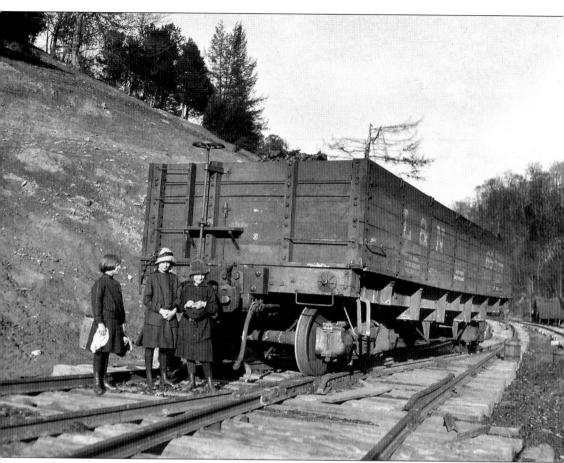

The two Kinner daughters, Ruth Farrel (left) and Lucille (center), and an unidentified friend pose here beside a wooden gondola on a track across the river from Hazard. His "carefully careless" technique is slightly evident in this setting.

Two

RIVERS WERE ROADS

Wagons were the common carriers between Hazard and Jackson before the railroad. Grace Guerrant, the young daughter of E. O. Guerrant, who came to the mountains to organize a church in 1896, wrote a letter to her sister describing the trip from Jackson to Hazard: "We went up the Kentucky River ten miles to the mouth of Troublesome Creek. . . . We had to get out and help our buggy down the rocky stair steps in the road. . . . We saw coal mines sticking out of the mountains. At times we rode over solid coal beds. . . . When we rode over the rocks we couldn't keep our hats on. . . . We had a hard time getting down the mountain. The path was so steep and sidelong. . . . We got down to the foot of the mountain by the hardest work. . . . The road to Grapevine was no road at all. . . . It took five hours to go seven miles."

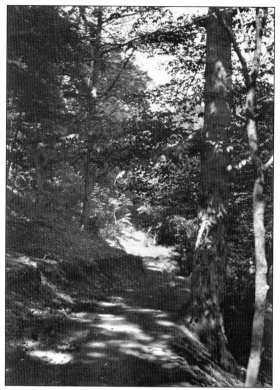

This photograph by Kinner shows an example of the territory he documented during the acquisition process by the L&E. Obtaining the land for the railroad right-of-way was the task of agents in Breathitt, Perry, and Letcher Counties employed by E. S. Jouett, the L&E's chief attorney. An early survey called the Walker Survey was used for charting right-of-way. Their assignment was to find a route that would be cheap to construct and economical to operate, and would reach the maximum number of coalfields.

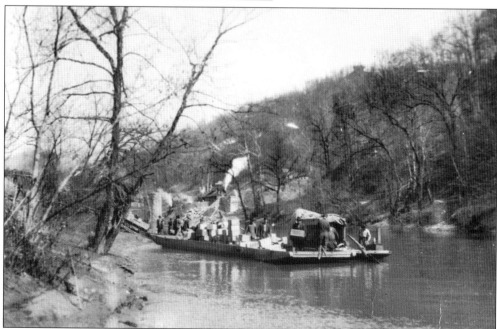

Although the North Fork of the Kentucky River in Perry County was too shallow for steamboats, the river was navigable for flatboats carrying up to 30,000 pounds. Before the railroad came to Eastern Kentucky, freight and household goods from Winchester or Mount Sterling were hauled overland to Irvine or Beattyville and then loaded onto flatboats bound for Jackson and Hazard.

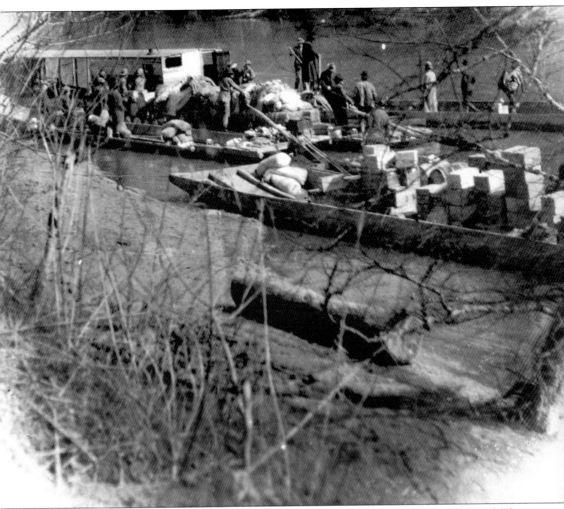

In 1891, the railroad reached Jackson, bringing shipments by land that much closer to Hazard. The last important function of the flatboats, also known as pushboats, was to move railroad-building equipment up the river from Quicksand. When modern transportation finally arrived, boatmen were the first to suffer the loss of their livelihood as river travel declined.

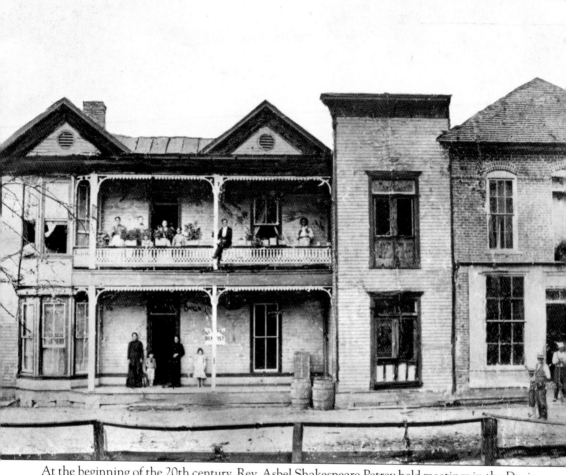

At the beginning of the 20th century, Rev. Asbel Shakespeare Petrey held meetings in the Davis Hotel when he was planning the establishment of a Baptist church. Railroad organizers stayed in this hotel. Fulton French boarded in a back room in 1889 during the French and Eversole feud. The entrance to the section on the right is behind the barrels.

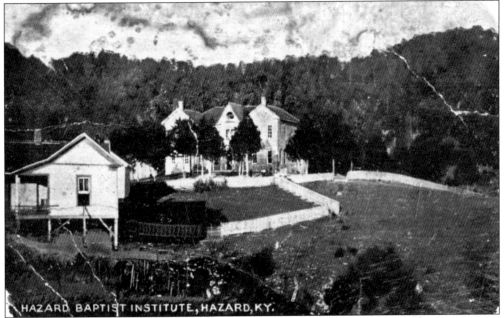

HAZARD BAPTIST INSTITUTE, HAZARD, KY.

The Hazard Baptist Institute (HBI) was founded in 1903 through the efforts of Rev. A. S. Petrey. Reverend Petrey and several businessmen of Hazard bought 2.4 acres of land in the Backwoods for $250. Bricks for the first two buildings were made in Hazard, and lumber was prepared at the Hazard Lumber and Supply Company. Lime and other materials were brought by wagon with great difficulty from Jackson, the nearest rail point.

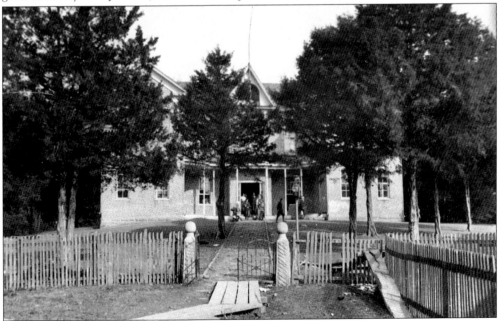

Reverend Petrey was the first president of the HBI board. He chose outstanding men in the community to be on the board. The auspicious group was Bailey Wootton, Dr. Elihu Kelly, Jesse C. Boggs, John L. Johnson, Joe E. Johnson, William G. Cornett, Will O. Davis, Rev. James Hall, Rev. W. M. Baker, Pearl Combs, Judge A. L. Begley, and B. P. Bowling.

Reverend Petrey's philosophy of education included the idea that the school needed to be set on top of a hill overlooking the town. The HBI campus was often the center of community activities. The school brought a number of outsiders to Hazard, and many of them stayed and made Hazard their home.

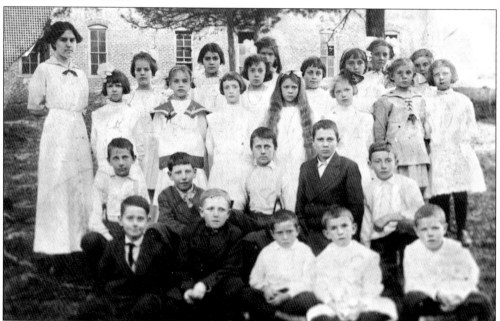

These students attending HBI in 1911 are, from left to right, (first row) unidentified, Jonah Daniel, Kelly Deaton, Byron Brashear, and Paul Petrey; (second row) Ted Baker, Charlie Baker, Prent Baker, Roderick Deaton, and Asbel Walker; (third row) Eunice Baker Fitzpatrick, Ruth Farrel Kinner, Blanche Davis, Glenna Wheeler, Molly Eversole, Verdie Wheeler, unidentified, and Lillian Eversole; (fourth row) unidentified, Lucille Kinner, Mildred Miller, Zaida Baker (the taller girl partially hidden), Marie Petrey, and three unidentified students.

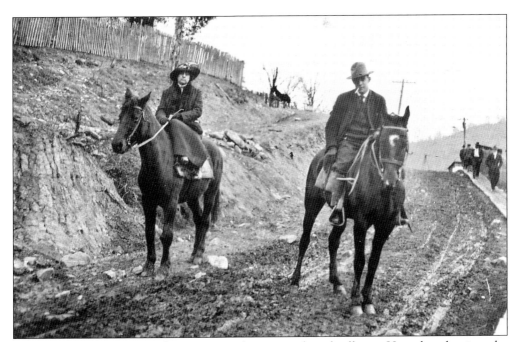

The road in this picture is characteristic of streets and roads all over Hazard at the time the railroad was completed in the summer of 1912. Residents and visitors alike were concerned that the streets remained unpaved even after the construction of several modern buildings and housing developments. The first street that was paved was in front of the courthouse.

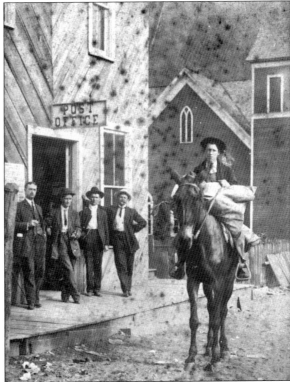

This is typical of the way mail was transported until the time the railroad was extended to Hazard. Mail wagons called hacks also carried the mail with more difficulty. At the time this picture was taken, the post office was on Main Street beside the lane adjacent to the Baptist church. This wooden church was built in 1898. (Special Collections Library, Alice Lloyd College.)

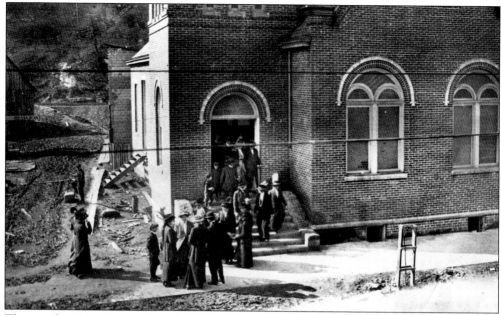

The wooden First Baptist Church building burned in 1910, and right away, Rev. A. S. Petrey proceeded to build another church. It was possible to make bricks on site, and there was a wealth of lumber available, but the same drawback existed as with the building of the school: other materials had to be transported by pushboat on the river from Jackson. The flatboat carrying doors and windows was frozen in the river seven miles from Hazard. The church stood freezing in the winter wind.

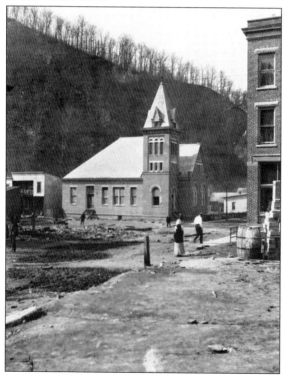

Reverend Petrey sent wagons pulled with oxen to bring in the valuable freight. All the pieces were delivered to Hazard without any broken glass early in 1912. The First Baptist Church in this Kinner picture was dedicated in 1912. Pews were brought in by one of the first freight trains to arrive in Hazard. Susan Combs Eversole (in the long skirt) stands on the spot where the house of her father, Josiah H. Combs, was located in the 19th century. The corner of the building on the right is the Beaumont Hotel.

Three

CAMP 4

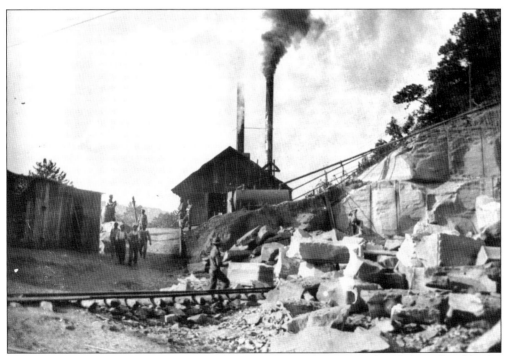

Workers lived at Camp 4, close to the quarry where stones were cut to build the railroad bridge at Combs, Kentucky. A great majority of European laborers were accompanied by their families. They moved along the line as tunnels and bridges were completed.

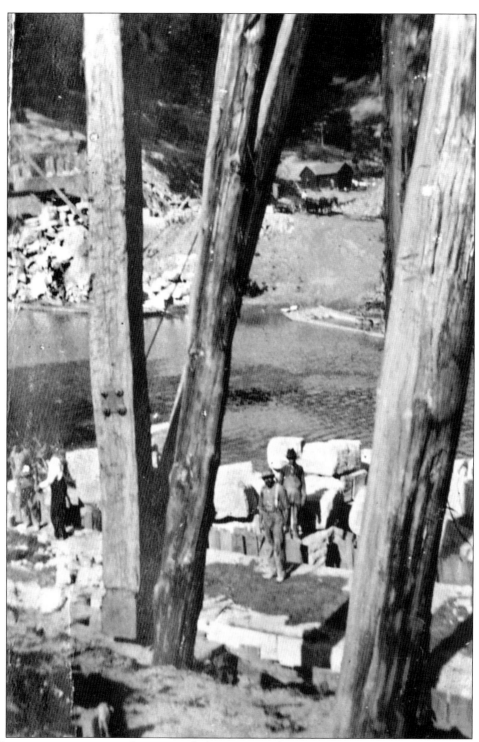

This camera perspective of quarry work demonstrates the enormity of the task of cutting huge chunks of stone for building the bridge. Engines provided power for cranes that lifted large stones and moved them into place.

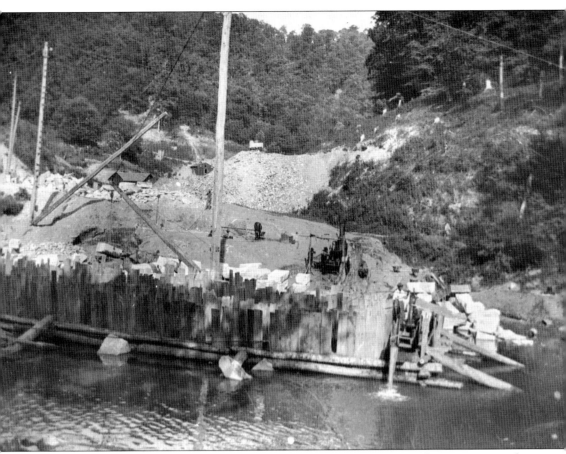

Here Kinner shows the building abutments for the bridge near Camp 4 on the Lexington and Eastern Railway (L&E). This railroad bridge is still being used today. It runs above the access road to Cherokee Hills just off Highway 15.

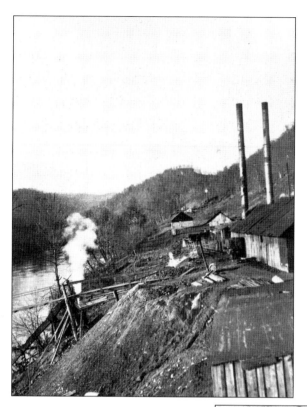

The powerhouse at Camp 4 furnished energy to a compressor for drilling and blasting the Hazard Tunnel. Fred Bryant, a young man from Jackson, was in charge of the plant. He was employed by the Jones-Davis Company, one of the companies contracted by L&E to build the railroad from Jackson to Hazard.

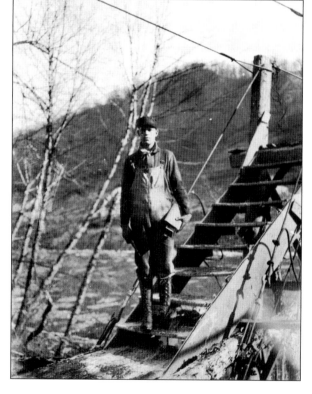

Fred Bryant, standing next to the bridge that crossed to Camp 4, ran the gasoline engine on the boat that carried boilers and compressors to the Camp 4 plant site. When the plant was completed, 18-year-old Bryant received a promotion to master mechanic. His salary was $75 a month plus room and board. While he lived around Hazard, he assisted the *Hazard Herald* with maintenance on their printing machines.

This scene is on top of the mountain directly over the tunnel. A pipe carrying air for the drills is visible in the foreground. Dwellers of Camp 4 walked on this road across the mountain to the east end of the tunnel, down to the bridge, and over to Hazard. This road was used to haul supplies to the other side of the mountain before the tunnel was completely cut through.

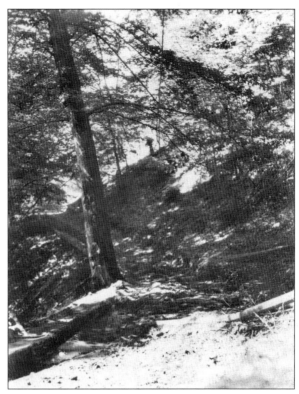

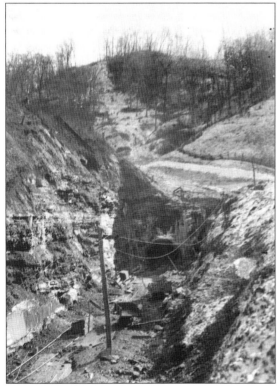

Laborers digging the tunnel suffered two major cave-ins in August and September 1911. Progress was delayed. Observe the path going over the mountain in this picture and also in the picture above. People from Camp 4 used this path to walk to Hazard.

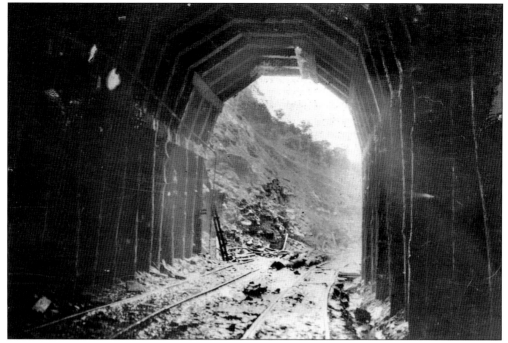

The work at the west end of the Hazard Tunnel was resumed in early October 1911 after the cave-ins of the preceding two months. Despite many disastrous slides during the winter, the tunnel was finally punched through on the Hazard side on March 15, 1912.

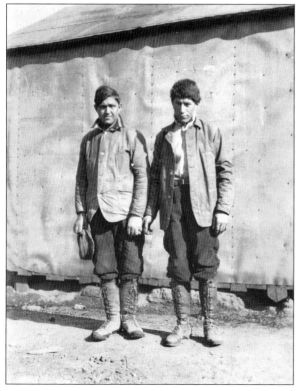

These two men from Camp 4 were trapped in the collapse of the tunnel. The man with the cap in his hand was fastened by a falling rock that crushed his foot. He was wedged in the tunnel for 48 hours. Townspeople who were working to save the young man stated to the newspaper reporter that they were in awe of his courage and patience as they got to know him throughout the terrible tragedy.

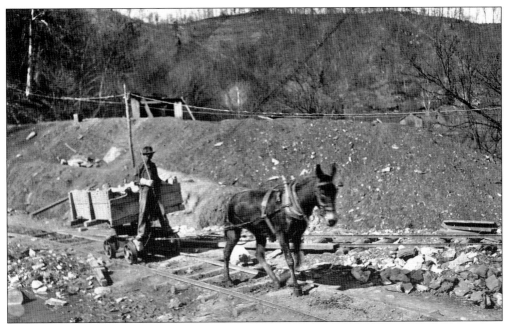

This picture shows the method that was used to move debris out of the tunnel. At this time, tools and equipment used for digging the tunnel were still being transported on flatboats. We see from this photograph that the design of this cart on rails and pulled by the mule is similar to "corn sleds" that mountain farmers used where wagons would not go. Corn sleds were narrow and low to the ground with runners made of sourwood.

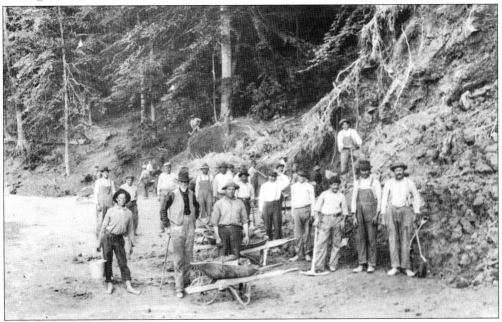

Workmen like these European laborers were some of the approximately 6,000 men who worked on building the line from Jackson to McRoberts. Roof falls and bad weather caused delays. A conservative estimate of the earth and rock removed in grading the railroad from Jackson to McRoberts was around 7.5 million cubic yards.

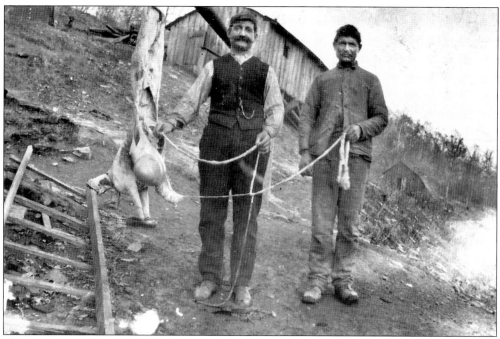

These two men from Bulgaria butchered a sheep at Camp 4. The Europeans brought with them many of their own traditions that were different from those that Eastern Kentuckians were accustomed to. The laborers' lives served as an education to those who wanted to learn how people from other countries lived.

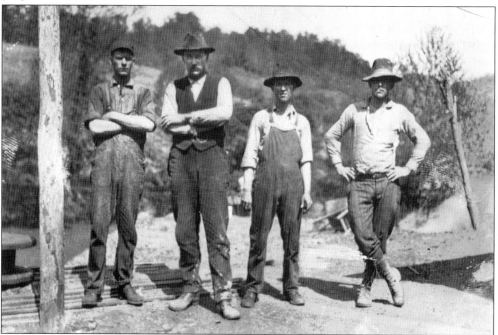

These men are unidentified except the tall one, who was the walking boss at Camp 4. Kinner identified him only as Mr. Chapman. The other men, all employed by the Jones-Davis Company, were his assistants.

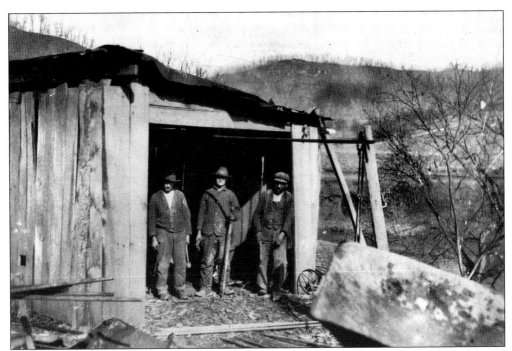

In the blacksmith shop shown here, work included keeping all the horses and mules well shod and producing parts from metal that were needed to make sure machinery kept working.

Workers in the camp came from Czechoslovakia, Bulgaria, Romania, and Italy, among other European countries. The man on the right in this picture is an interpreter. He could speak all of the seven languages in Camp 4. Their names are unknown.

The dwarf smoking a cigar in this picture was the camp mascot. It is not known who he was or if he worked in the tunnel or the quarry.

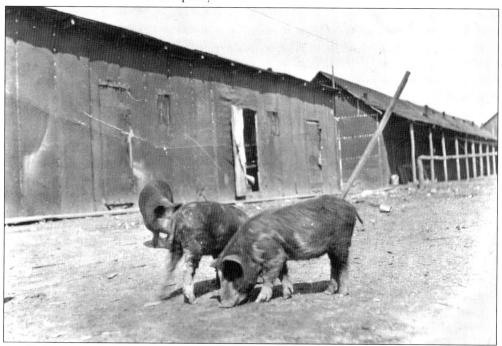

Crude sleeping and living quarters were thrown up temporarily so they could be moved quickly to the next finishing point. The residents of Camp 4 grew some of their own food. Kinner wrote on the back of the picture that this was "our pork on foot."

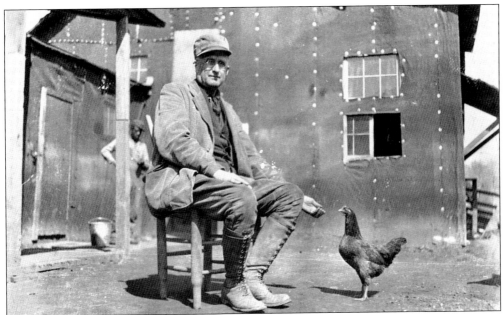

P. B. Winn, auditor and paymaster of the L&E Camp 4, takes some time off to feed the camp chickens. His face was well known around Hazard when he and his corps of assistants came to issue paychecks. The local newspaper noted that in July 1911, Mrs. P. B. Winn from Lexington visited Hazard and Camp 4. The *Hazard Herald* also reported that after Camp 4 broke up, Mr. Winn was planning to return to Lexington.

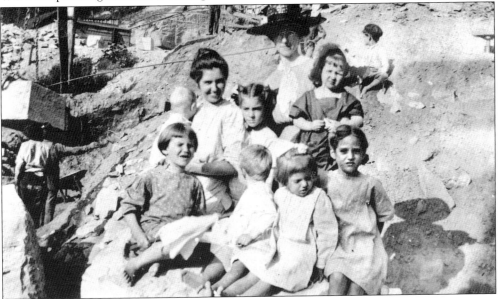

Two women and eight young children from Camp 4 appear here in an incongruous setting as they sit happily on the edge of a rock where cranes are lifting and moving enormous stones that will be used in the foundation of the bridge at Combs. When John Kinner was photographing the operation for his work with the L&E, he also captured this very unusual scene. The children are all washed and pressed, their hair combed. They might have come to visit their fathers and perhaps bring lunch.

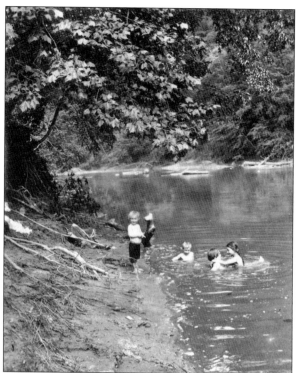

Here, in a candid Kinner photograph, children are engaged in the perennial form of entertainment in the summertime, taking a swim in the North Fork of the Kentucky River. Camp 4 children probably attended school in Combs, as it was the nearest community that had a school.

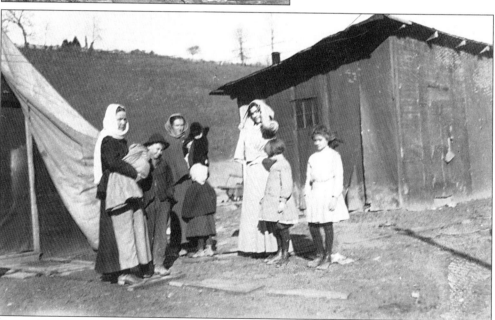

Camp 4 families in this picture dressed warmly for colder weather. The three on the right appear to be Kinner's family. When this section of the railroad was completed, the camp moved to the next construction site and on towards the end of the line at McRoberts. After Camp 4 disbanded, the Daniel Boone Coal Company established a coal camp in the same location and purchased the Jones-Davis Company machinery. A town grew up around Camp 4 named Lennut—the reverse of "tunnel."

Kinner identified this as the east end of the Hazard Tunnel after it was completed in 1914. Three men in charge of the work preceded Dewey Daniel as the first to walk through the tunnel. On Sunday, March 17, 1912, a large crowd took advantage of the beautiful weather by walking through the tunnel. On March 20, the first rails were laid in Perry County, and two months later, the tracks reached the west end of this tunnel. Kinner slyly positioned his daughter in this picture of the tunnel.

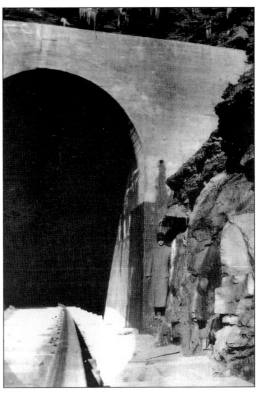

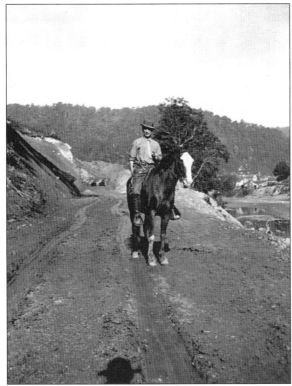

The man on the horse was a timekeeper who rode along the railroad grade across the river from Hazard. The route that he traveled each day was between the Hazard Tunnel and Viper.

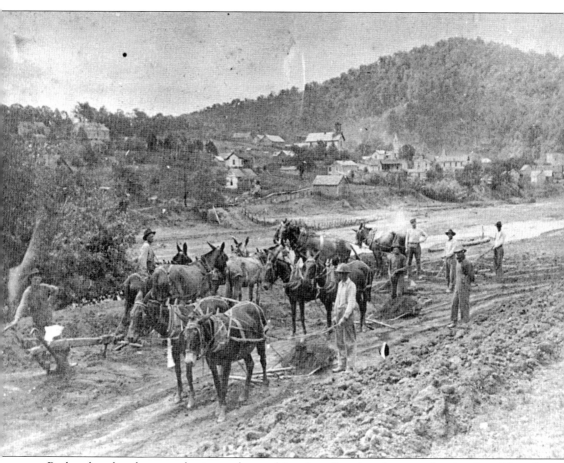

Railroad workers here are plowing and smoothing the railroad grade across the river from Hazard. The July 6, 1911, *Hazard Herald* commented that Mr. Richards, manager for Jones-Davis Company, was planning to rush the grading work on the section across from town. After grading, the next stage was track laying, to be followed by the carpenters who built section houses and depots. The cost for each mile was $52,500. In one stage in the grading process called ballasting, rocks were used to level the ground under railroad ties. The steeple on the right belongs to the Hazard First Baptist Church. The tallest building in the background is the school on High Street. At the time the picture was taken, the school was only one story.

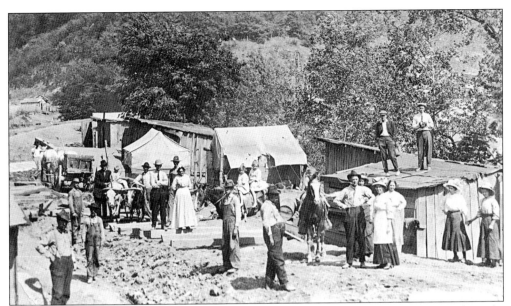

This camp of T. W. Smith built the stonework for the bridge at Typo. Mr. Smith is in the right foreground with the women near the horse. Several people are standing on a stack of railroad ties. When the photographer came by, the whole group of people stopped working to pose for the camera.

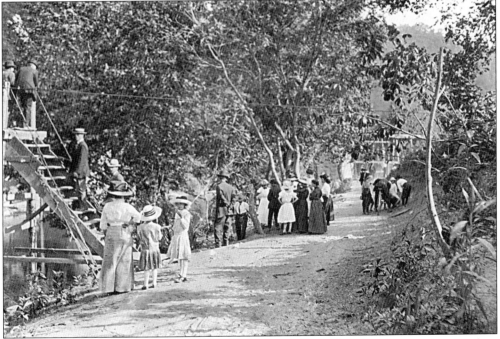

The wooden steps on the left led to the cable bridge at Camp 4 at the river crossing. Workers had to climb the hill to get to Hazard. Everyone is dressed up in his or her "Sunday best." Mr. Kinner did not name an event or give a reason for taking this picture. This candid shot has become one of his classic portrayals of Camp 4 at that time. The three in the foreground could be Kinner's family.

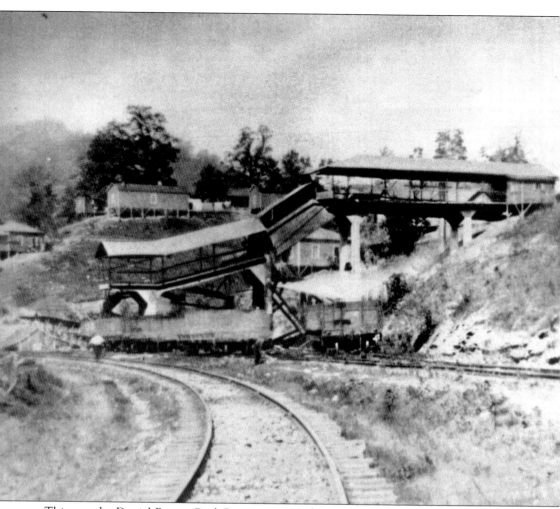

This was the Daniel Boone Coal Company tipple located at Lennut. Records show there was an agreement between the coal company and the Louisville and Nashville (L&N) Railroad to furnish rails, spikes, splices, bolts, and switch rigging to build a low-grade railway not exceeding 2,040 feet diverging from the East Kentucky Division of the L&N Railroad. Although the L&N owned the L&E from November 1910, the L&E was not conveyed to the L&N until October 5, 1915, due to litigation over another line adjoining the L&E.

Four

TRAIN TRAVEL ARRIVES

This winter scene is a rare view of the property of Josiah H. Combs, the future site of the Hazard Yards, across the river from Hazard. It appears that grading was started before the snow. From a newspaper in January 1912, we learn that work was discontinued until better weather in late winter or early spring. The shacks scattered about in the picture were built to house railroad equipment.

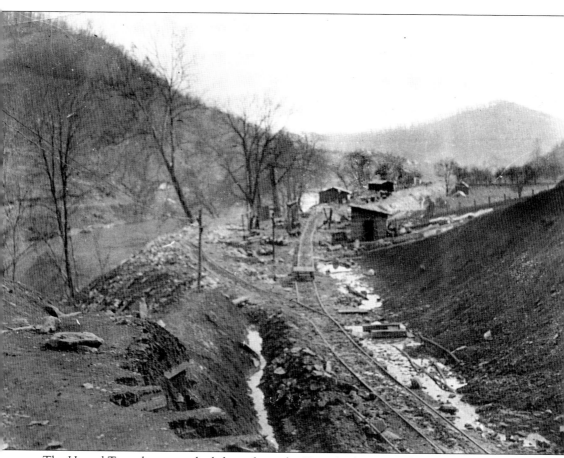

The Hazard Tunnel was punched through on the Hazard side on March 15, 1912. These tracks are just outside the tunnel on the east end and continue on along the river across from Hazard.

Some people, like this unidentified woman, used stepping stones to cross the river to meet the first train on June 17, 1912. The first bridge (pictured below), a footbridge built of planks from bank to bank supported by wooden sawhorses, was so narrow that several people were known to have fallen into the river while attempting to go across. A small tide later split apart this fragile structure. Other pedestrians struggled down the muddy bank and paid 5¢ to cross in a john-boat, also called a jow-boat (pronounced "joe").

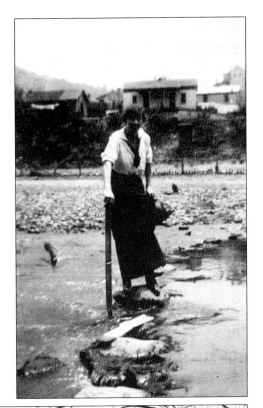

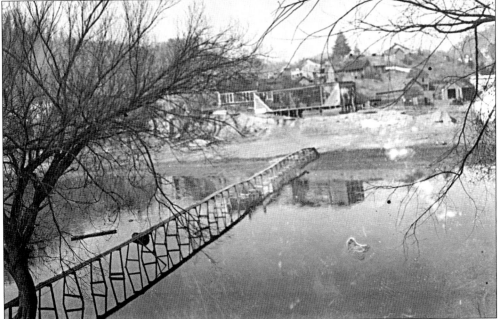

Dr. Elihu Kelly had just begun to build the structure pictured here when the first train arrived in 1912, and he finished it by the end of the year. The walking bridge that is shown here, crossing the river at the Hazard Station, was the perilous bridge mentioned above. It was difficult to cross in good weather and impossible in bad.

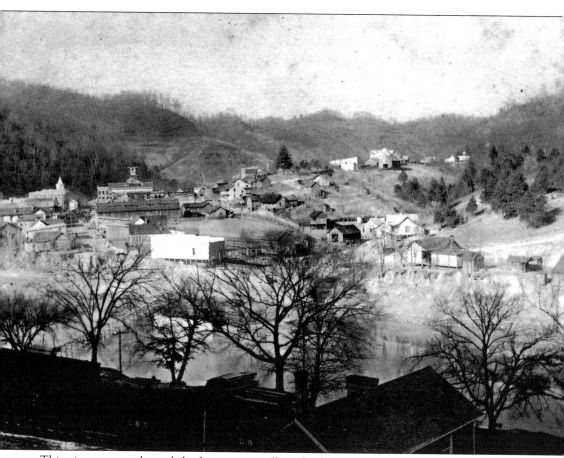

This picture was taken while the narrow walking bridge was still being used to cross from the Main Street side of the river. At this point, Dr. Kelly's building was completed. The hill on the right was Isaac Baker's farm. Isaac's father, John Baker, and his family came from Bakersfield, North Carolina, in 1811. Isaac was born on the mouth of Second Creek before they reached the settlement that was later Hazard. He married Elizabeth Griffith, a Cherokee woman, and they had 10 children. The Hazard patriarch lived to be almost 100 and is buried in the Baker Cemetery on the old Baker family farm, which is now in the Bobby Davis Park.

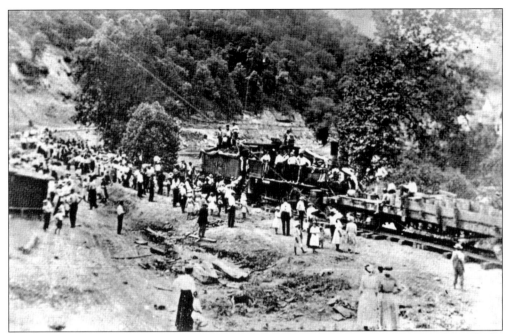

On Monday, June 17, 1912, the special rail-laying train pushed by Engine 324 made tracks by dumping the ties and laying the rails as it went along the previously graded bed. Rails were laid at a rate of around one and a half miles a day. A number of young ladies mounted the engine and track-laying car and decorated it with flowers and bunting.

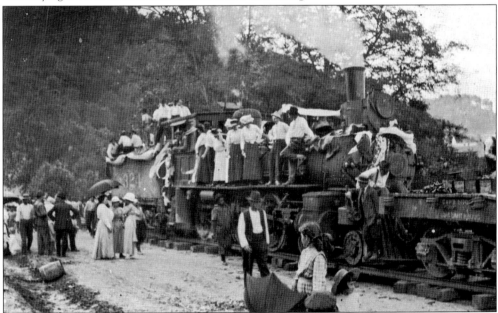

At noon, the train reached the opposite side of the river from the Perry County Court House. The Hazard postmaster, John Baker, and Lige Cornett, the last man to take a boatload of coal to market, spoke on how long they had waited to see the train come to Hazard. Calloway Napier, the county attorney, was called on to speak, and he expressed his delight at this occasion. Then he spoke glowingly of the bright future of Hazard after 25 years of planning for the railroad.

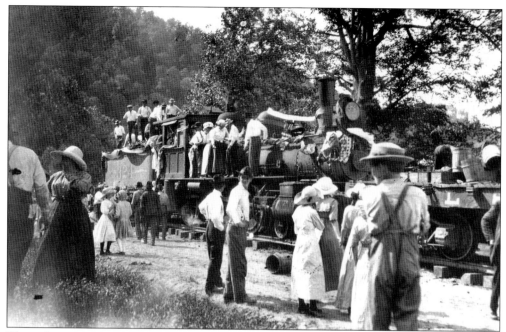

The welcome committee wanted to have other speeches, but the crowd was too busily engaged in looking at the work of the crew as they put down rails. The front page of the June 20, 1912, *Hazard Herald* proclaimed "Band Plays Glory Hallelujah." The spirit of optimism and excitement was felt throughout the community.

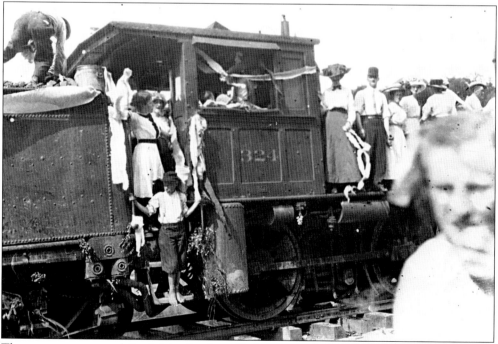

The newspaper reported, "early Monday, June 17 almost everybody was seen wending their way to the upper side of Messer Branch . . . to welcome the steam horse." A barrel of cider was opened, and everybody drank to the future of the town and its people and also to the railroad.

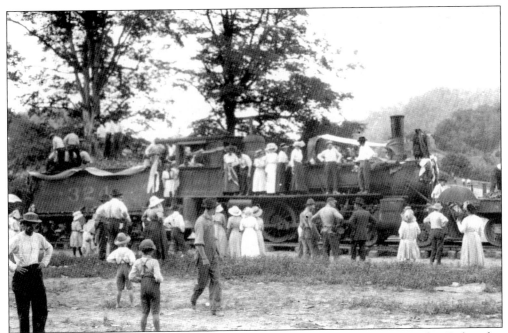

The arrival of the railroad to Hazard changed the life of the community in one day. Before this monumental event, travel was burdensome, and in certain weather, it was not possible. Overnight the one-and-a-half-day trip to Jackson changed to a round-trip that could be taken in one day. The little town that was landlocked entered into the 20th century.

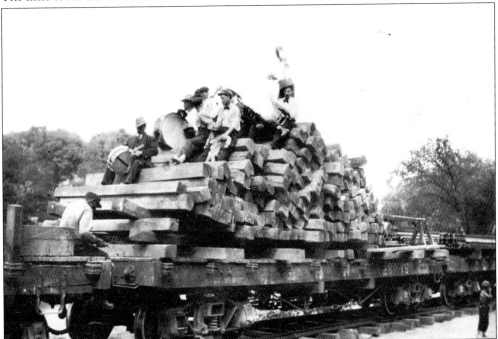

The Hazard Band was out in full force and helped to keep up the enthusiasm of the crowd. The band boys, mounted on a pile of crossties on a flatcar, made an escort to the happy assemblage of young ladies.

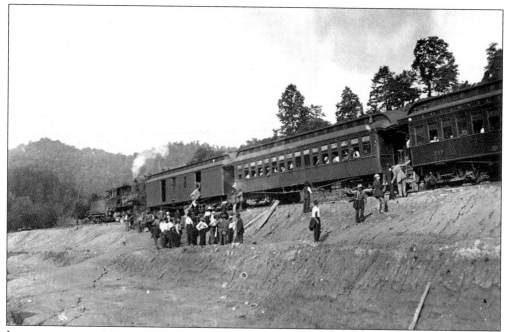

In an interview on June 15, 1912, W. A. McDowell, general manager of the L&E, announced that regular passenger service would begin between Hazard and Jackson in 10 days. As predicted, the first passenger train pulled out of Hazard at 7:00 Tuesday morning, June 25, bound for Jackson, beginning a new era for the people of Perry County.

Most of the people on the first passenger train were making the trip simply for amusement and not with any specific destination. Mr. Sherman H. Campbell of Yerkes, pictured here in his later years, had the distinction of riding on the first passenger train out of Hazard in 1912 and also riding on the last passenger train that left Hazard on June 14, 1956.

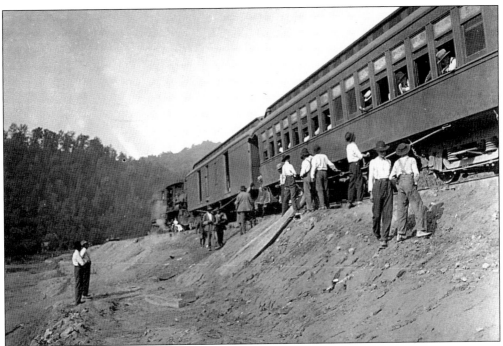

The first passenger train consisted of a combination of a coach and a baggage car, a partition coach for smokers and African Americans, and a first-class coach. In this picture, the passenger train is on the track at Camp 4.

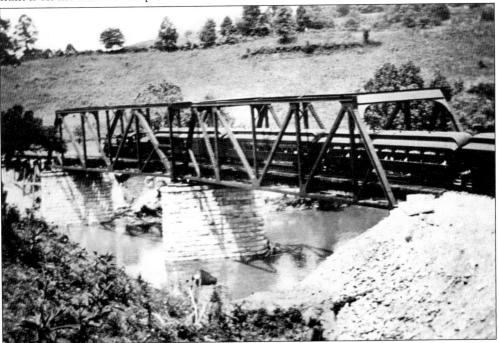

John Kinner captured the moment of one of the first passenger trains traveling through the bridge at Combs. This is the same bridge that was built by the workers living in Camp 4. The train trestle pictured here is still being used in 2006.

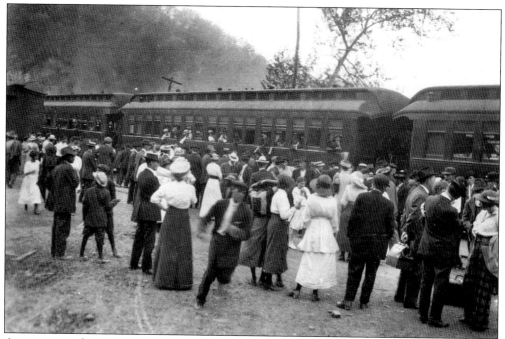

As many outsiders were moving into Hazard, a promising sign of the time was also the number of young people who were departing. This fact was not regrettable, because the youth were now able to travel more easily to various colleges throughout the country.

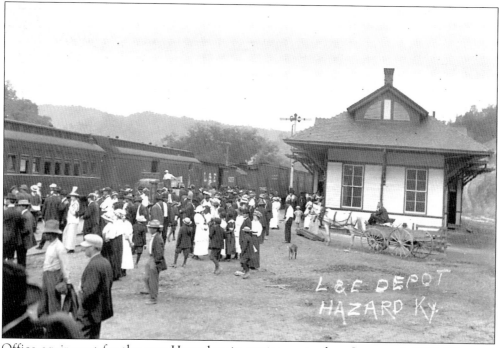

Office equipment for the new Hazard train station arrived on January 5, 1913. The new depot provided the people of Perry County another opportunity to express their pride in the town's progressiveness.

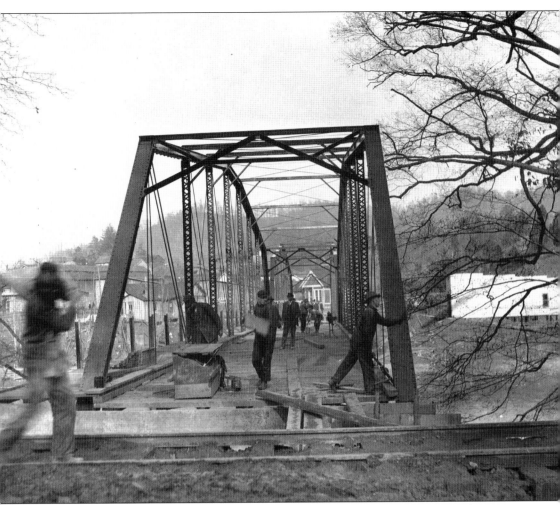

By January 9, 1913, the new bridge from Main Street across the river was progressing; however, the depot was completed first. Disappointment was evident in this editorial comment from the *Hazard Herald*: "Work on the bridge has advanced mighty slowly, and has resulted in material inconvenience since the heavy rains began. All possible effort was made by the bridge company to have the work pushed, but it did no good."

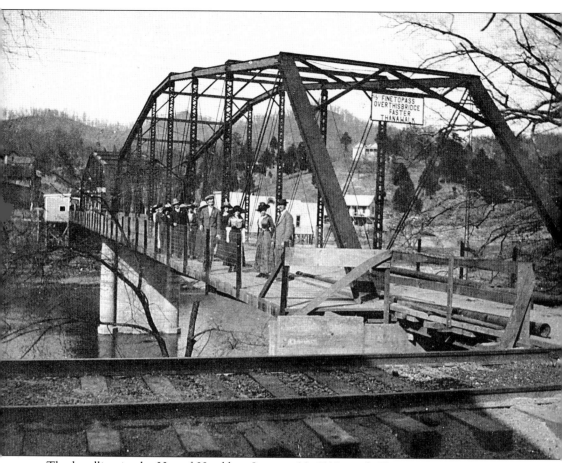

The headline in the *Hazard Herald* on January 30, 1913, read: "Come Down With Your Toll." The article explained, "The passengers to and from the depot are met this side of the new bridge by Mr. Jesse Wooton, who is now playing the role of toll gatherer. . . . It is one cent for animals walking on two feet, such as men, women, boys, and girls. If on horseback, there is a nickel to pay; if one is riding in a one-horse wagon or carriage, or if it has two horses attached, it is ten cents. Cattle in herds . . . are charged at a rate of one cent a head, just like human beings. The first day's toll collection was over $7.00."

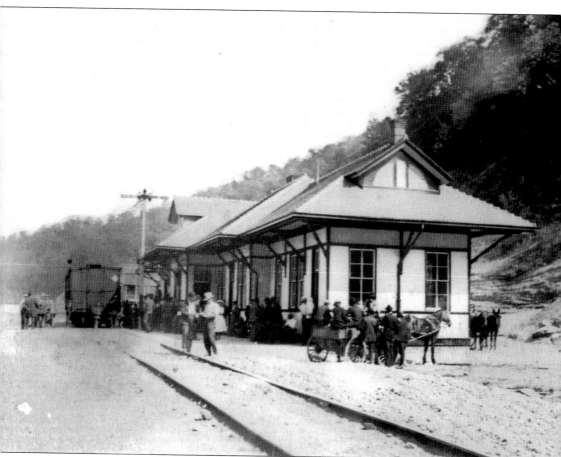

Col. W. J. Lampton, a native Kentuckian living in New York, objected to the term "depot." He wrote a letter to the *Hazard Herald* saying that when writing of the beautiful structure across the river in Hazard, it should be referred to as a "station." Colonel Lampton, an admired writer in the early 20th century with articles in the *Saturday Evening Post* and *Woman's Home Companion* and a reader of the *Hazard Herald*, insisted that a depot is like a warehouse where freight is kept. Lampton wrote, "Call it a 'station' and stick to it till everybody who is progressive and proper . . . does likewise."

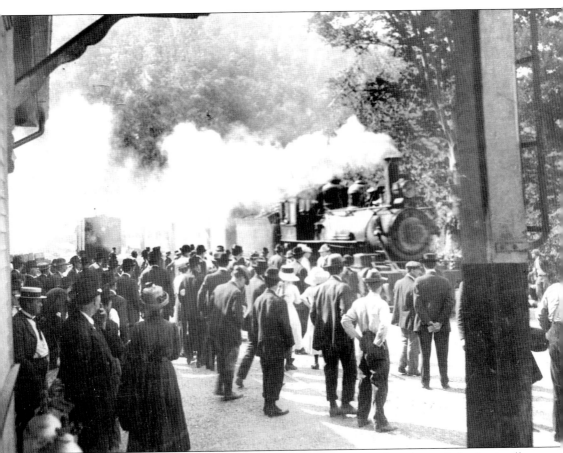

At 3:30 on Thursday afternoon, May 22, 1913, Hazard townspeople welcomed the Louisville Boosters on their tour of the new L&E Extension. The special booster train was six hours late. A wreck in one of the tunnels had to be cleared in front of the boosters' train, but the spirits of the cheering crowd at the Hazard Depot remained high.

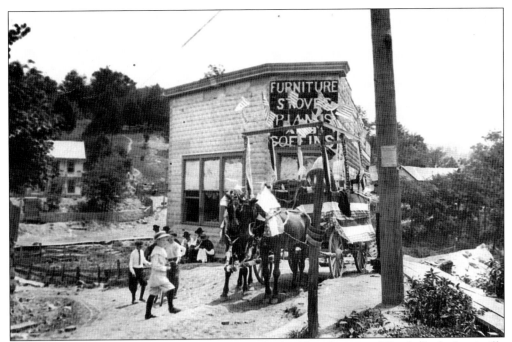

A decorated wagon was parked in front of Dr. Kelly's building (see page 40), which the Louisville Boosters would pass by on their way to the courthouse. The store was opposite the tollbooth on the east end of the bridge a few feet from Main Street. The toll over the new bridge from town was waived for the occasion.

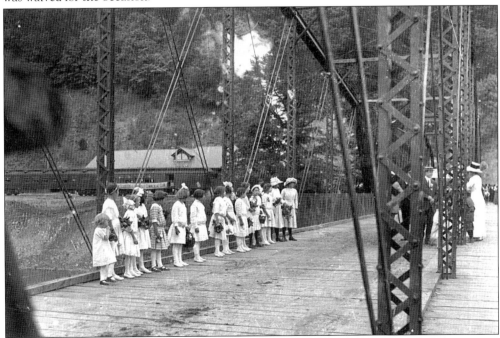

A group of Hazard girls all dressed in white showered the parade with flowers of all description. A banner across the bridge read "Welcome," and attached to the banner was the key to the city. Mayor W. O. Head of Louisville took charge of the key and the parade moved onto the bridge.

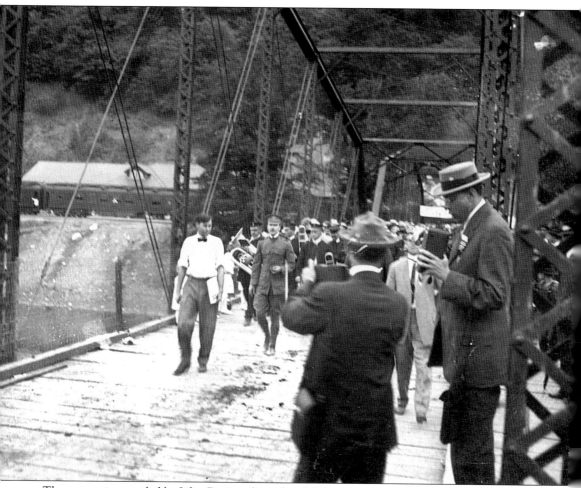

The procession was led by John Day's military band. The reception committee was next in line, leading the dignitaries across the bridge. Public figures included B. C. Tynes, an attorney who was the chairman of the committee on arrangement and who acted as master of ceremonies.

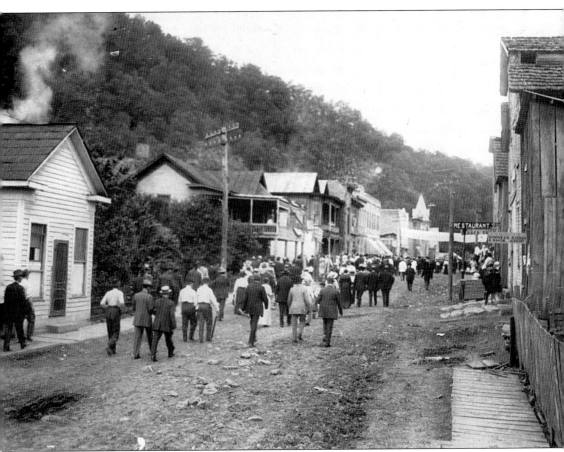

After arriving at the courthouse, the crowd was entertained with music and speeches. The band played *My Old Kentucky Home* and *Dixie*. Mr. Tynes introduced Hazard's postmaster and oldest merchant, John Baker, who offered a hearty welcome speech, followed by a few words from Ira Fields, the commonwealth attorney. The rest of the program was given to the visitors: Frank Cassell, Belknap Hardware Company; Thomas S. Tuley, Kentucky Manufacturers and Shipping Association; W. O. Head, mayor of Louisville; Dr. Bruner, the Perry Centennial Association; J. W. Newman, state commissioner of agriculture; and David Jackson, Louisville Tin and Stove Company.

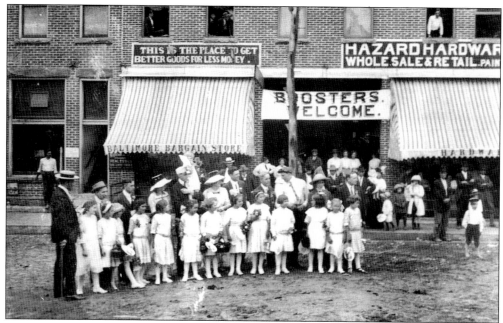

Young ladies from the bridge, showing Hazard hospitality to the Louisville Boosters, again lined up in front of the Baltimore Store. The sixth girl from the left is Lucille Kinner, and the eighth girl is Farrel Kinner, daughters of John Kinner. Tenth from the left is Glenna Wheeler, daughter of Mr. and Mrs. P. T. Wheeler.

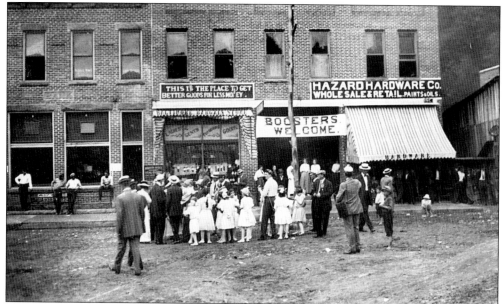

At 4:30, the boosters returned to the train to continue on to McRoberts. Business leaders in Hazard were hoping for the day when Perry County would be the center of the world's coal production, based on the rapid advancement they experienced in the year after the arrival of the railroad. The headline in the *Hazard Herald* on May 23, 1913, read "Prosperity's Vanguard," reflecting strongly the expectations and possibilities presented by the railroad. When the guests crossed back to the train, another banner said "Au revoir."

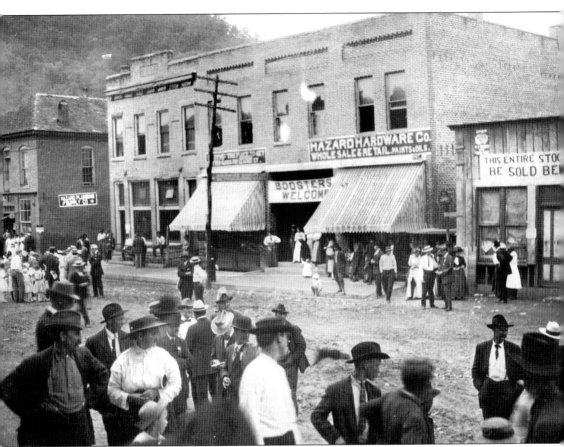

People stayed and milled around on Main Street after the boosters returned to the train. The building on the left is one section of the W. O. Davis Hotel. On the other side of the lane is the Perry County Bank. The Johnson building has two awnings: the Baltimore Store is on the left, and the Hazard Hardware Company is on the right.

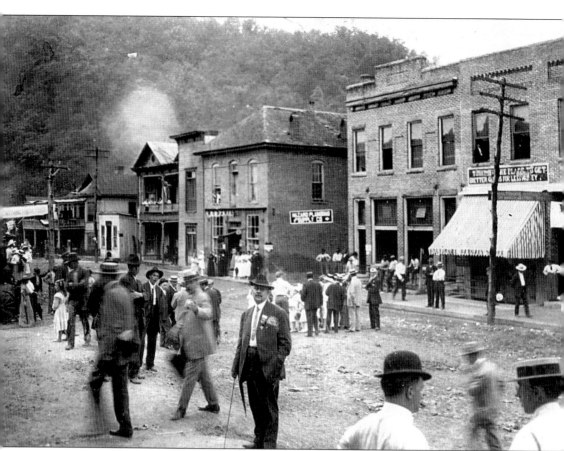

The central figure here in Kinner's photograph is Rev. A. S. Petrey, who organized the Hazard First Baptist Church and supervised the construction of the church buildings for the congregation. The structure behind Reverend Petrey that forms a cluster of buildings with three types of roofs is the W. O. Davis building. The building on the left, where the banner is hanging, is the D. Y. Combs Hotel.

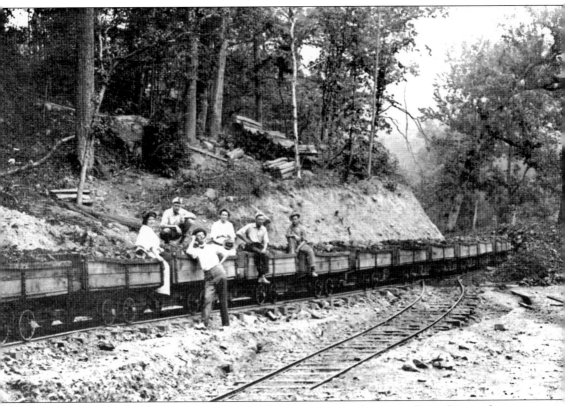

This photograph by John Kinner depicts the work in two main industries in Perry County. Logs on the hill are waiting to be collected and taken to the lumber mill. Characteristic of Kinner's approach, miners and friends, who look like they are in good clothes, are resting on a short-run train carrying coal on its way to a tipple to be screened and dropped into railroad cars.

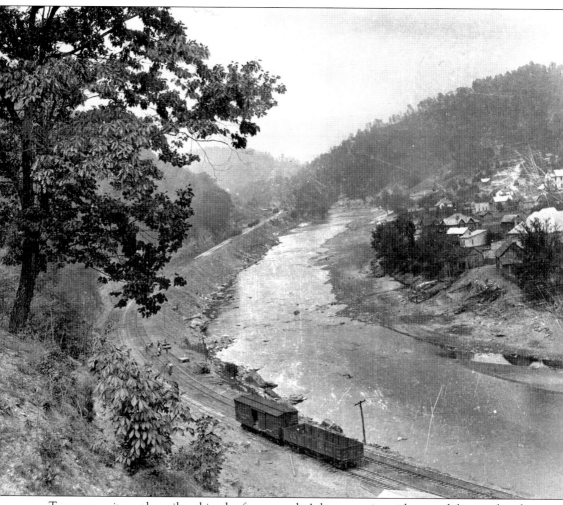

Two cars wait on the railroad in the foreground. A boxcar pairs with a gondola, a railroad car with no top, a flat bottom, and fixed sides that is used for hauling coal and other heavy bulk commodities. Men are working along the railroad tracks. The large church in the background on the town side is the First Baptist Church. The two-story building is the school.

Five

MAIN STREET

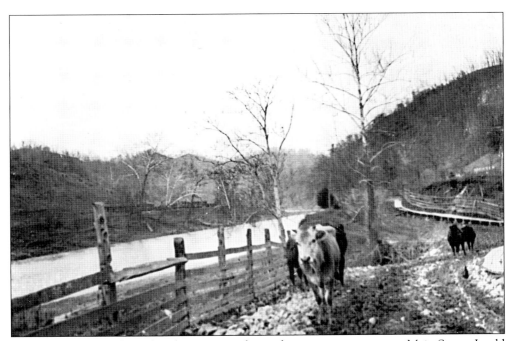

After the coming of the railroad, progress and growth was most apparent on Main Street. In old Hazard, livestock roamed freely on Main Street. As outside refinements previously held back by isolation found their way into town, efforts began to correct the provincial ways. This picture of a free-roving cow was taken on the north end of Main Street.

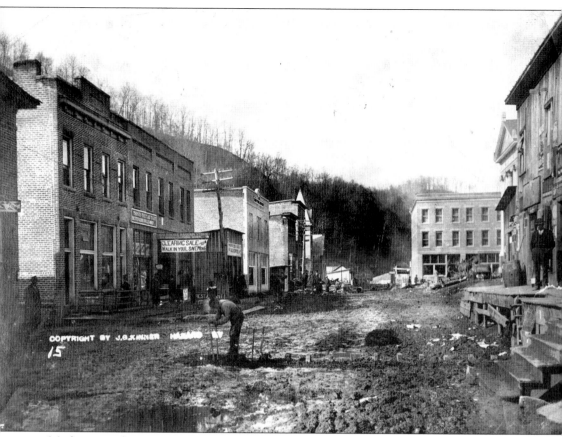

Mud was a subject of many editorials. Louis Pilcher, a visiting chronicler of Hazard's civic improvement, remarked on mud as the only "retarding demon." While he generally praised the progressiveness of Hazard, he related how his spirit was dampened by his experience on one Sunday morning with foot-deep mud. He wrote that while he was navigating the stepping stones on Main Street, he missed a step, fell down, and was baptized in "Mudlavia."

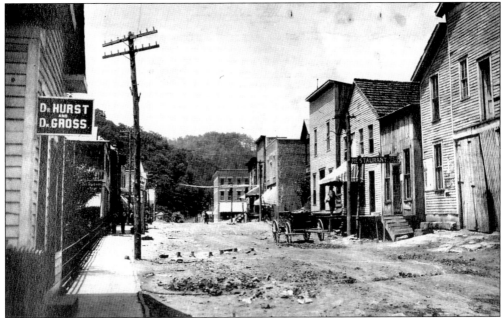

In *They Have Topped the Mountain*, Clara Wootton describes Hazard in the rainy seasons: "There were no pavements or sidewalks, except irregular stretches of boardwalk laid by the property owners. The crossings were a problem, for the steel-rimmed wheels of the occasional jolt wagon cut deep ruts. Stones were placed at intervals to make a crossing, and when the mud got too deep, crossties were driven endwise into the mud. It was a precarious footing, and it was not uncommon for a person to take a nose dive into the mud."

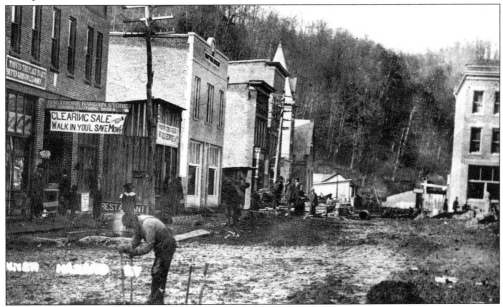

This is a detailed version of the photograph on page 60. The building on the left is the Johnson Building. The next one to the right is the Wootton and Morgan Building, then the First National Bank, the S. A. D. Jones Building, and the First Baptist Church. On the other side of the street, the Austin Fields Building is under construction.

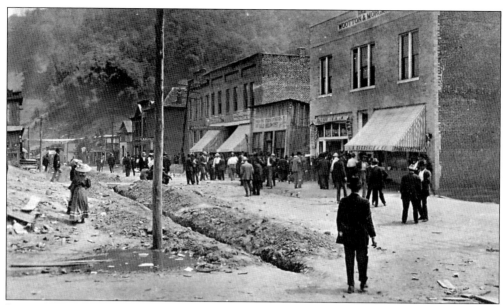

In an attempt to solve problems created by mud holes, the town board awarded John Sexton a contract in July 1911 (almost a year before the railroad arrived) to implement his plan to put a ditch on the upper side of Main Street. Water could then be diverted to the river by drains running at frequent intervals. The work was to be completed by fall to take care of the "fearful mud holes" of winter.

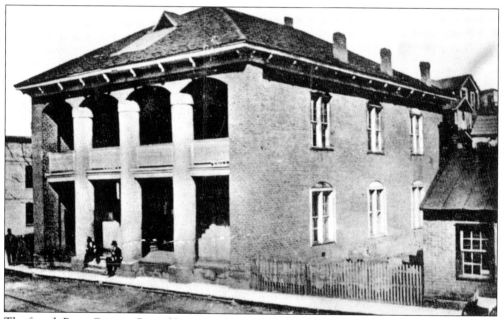

The fourth Perry County Court House was built *c.* 1884. Rev. E. O. Guerrant held church in this building when he was in Hazard in 1896. The Hazard Post Office was in this building in 1893, when William Cornett was postmaster. Court records stated that the courthouse was "insufficient, inadequate, dangerous, and insecure." The court proposed that $25,000 be appropriated for a new courthouse. A bond was proposed for the general election in November 1911. The old courthouse was destroyed by fire in June 1911, before the bond issue was brought to vote.

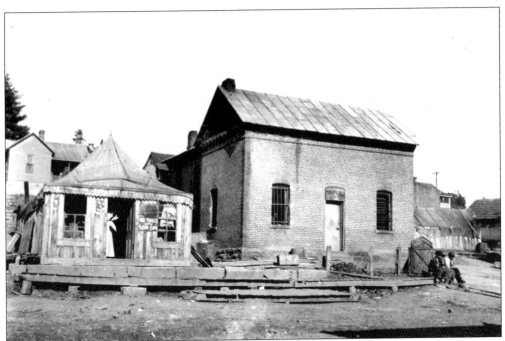

After the courthouse burned in 1911, Bob Baker, an enterprising young man in town, erected a tent and put in a restaurant for a few months. Observers often make the mistake of thinking that a woman is standing in the door. On closer inspection, it is clearly the sun casting a shadow.

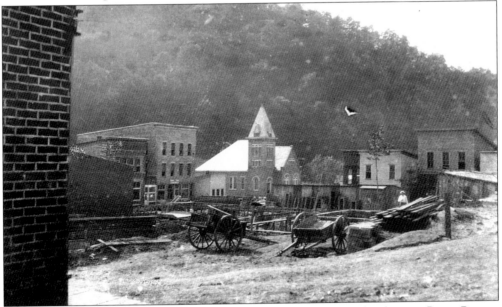

John Kinner took this photograph in 1912 during the excavation for the new Perry County Court House. The structures on the right were later torn down to make way for the Austin Fields Building, which housed the Beaumont Hotel. The First National Bank is partially obscured. The Prof. S. A. D. Jones building is between the bank and the First Baptist Church. The Jones Building provided space for the Perry County Fiscal Court while the courthouse was under construction.

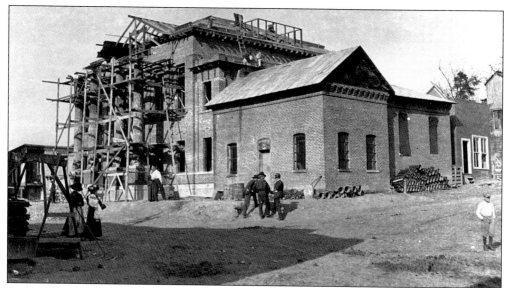

Fireproof bricks and materials for the courthouse could not be obtained until the railroad reached Hazard in June 1912. The cornerstone was laid August 14, 1912, and a mere six months later, on February 14, 1913, Perry County was presented with a Valentine's Day present in the form of a brand new courthouse.

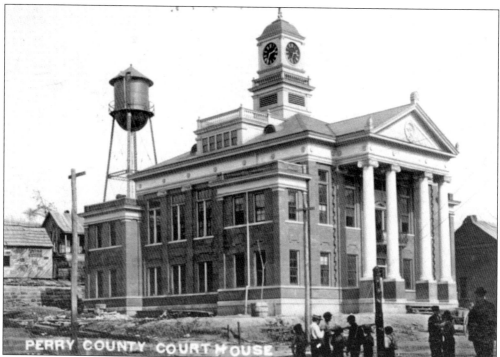

PERRY COUNTY COURT HOUSE

The new courthouse was a fireproof structure containing offices equipped with metal furniture and fireproof vaults. In addition to the courtroom, the building contained a conference room and private rooms for the judges, prosecuting attorney, grand jury, and two petit juries. The lavatory for the court officials was in the basement, along with the steam heat furnace. Public lavatories were in a small brick building under the water tank.

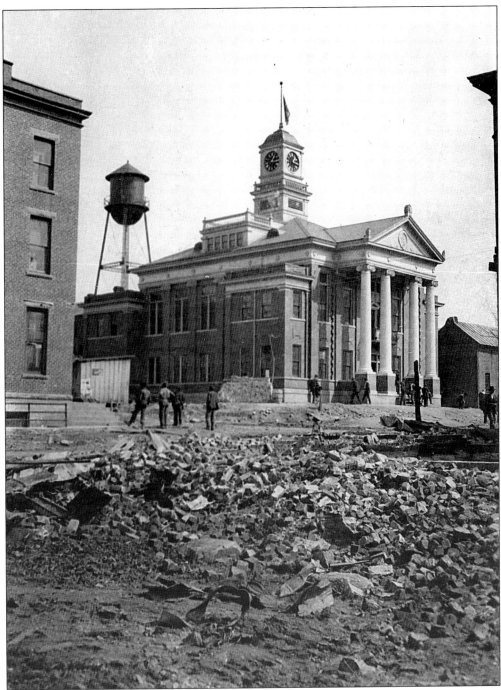

A three-horsepower gasoline engine pumped water to the 10,000-gallon steel tank 75 feet high from a 100-foot-deep well. The tank furnished water to the lavatories, but its main purpose was to supply water in case of a fire. A sewer line from the building carried waste to the river. The building was wired for electricity, and lights were on by June 1913. Debris on the street is partly due to the objectionable condition of the street and partly due to the construction of new brick structures on Main Street.

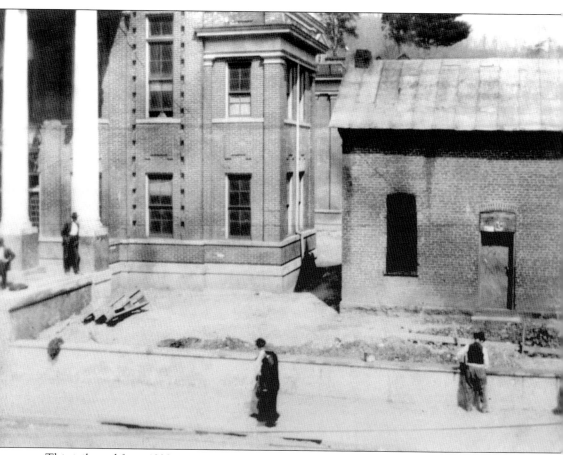

This jail, used from 1899 to 1914, was Hazard's first brick jail, costing $5,800 to build. The street on the right is the old Fleet Street. The first building on the far right is D. Y. Combs's building. Broadsides and posters nailed across the side publicized political candidates and announced

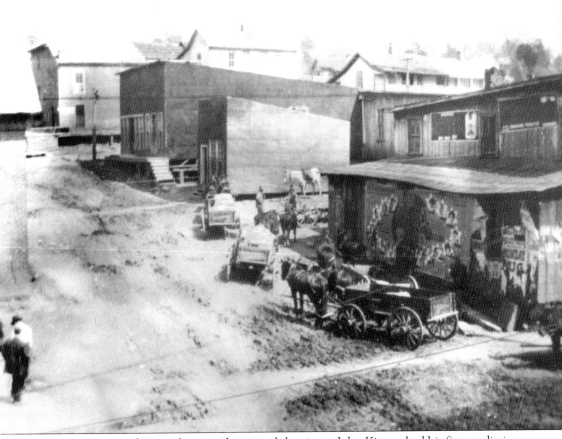

coming attractions such as performers, shows, and the circus. John Kinner had his first studio in the building at the top of Fleet Street, where wooden steps lead up to the entrance.

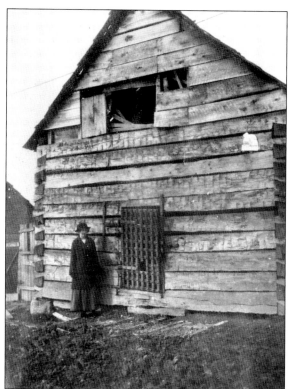

Allie Hendren, a teacher at the Hazard Graded School who arrived in Hazard in 1914 with several other teachers, is pictured in front of the primitive log jail that was used before the brick one. This jail stood on the corner of Fleet Street and High Street opposite the building described on the previous page as John Kinner's studio.

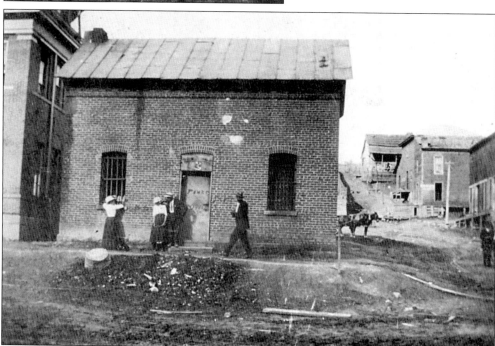

After the new courthouse was built, the community began requesting a new jail. Most people agreed that the jail beside the courthouse was outdated, dilapidated, and a disreputable eyesore. Inmates caused disturbances as they called out from inside the jail.

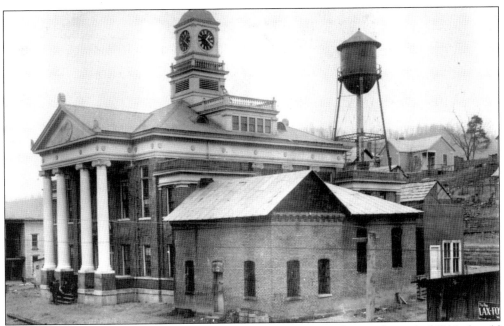

Even though the new jail farther down Main Street was occupied since the end of 1914, the old one by the courthouse still remained. There were continuous calls to have it demolished. This jail and the jailer's residence in the rear of the jail were a thing of the past, and it seemed that the whole town was tired of looking at it. This picture portrays the beautiful architecture of the new courthouse.

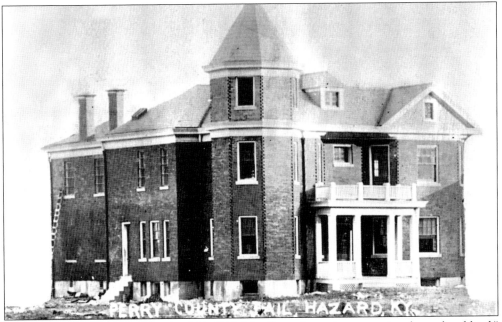

The *Hazard Herald* reported on April 29, 1915, "finally workmen began tearing down the old jail." By the end of the year 1915, the old jail was gone and the new jail in the northern part of town had been occupied for several months. The jailer, James Holliday, facilitated a careful and uneventful move to the new jail. The jailor's residence occupied the front section of the new jail building.

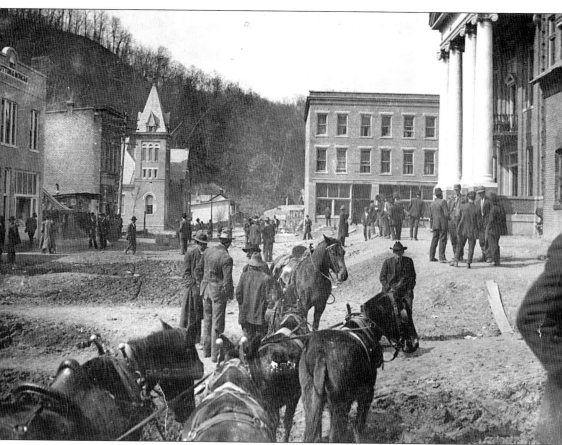

John Kinner identified this gathering as Court Day. It is a late winter day in 1913, after Prof. S. A. D. Jones's building between the bank and the church had burned. Court Day was a tradition that originated from an old English custom. On one designated day each year, citizens who lived all over the countryside would come to town to do business they had with the court. Farmers brought livestock to town to sell and trade. They visited with friends they had not seen recently.

In 1896, Leon and Morris Berkowitz arrived in New York from Rumania. In 1910, they moved to Pineville, Kentucky. Then they came to Hazard and opened the Baltimore Store in the Johnson Building opposite the new Perry County Court House. They actively advertised good-quality merchandise at low prices. After opening in September 1912, the Baltimore Store became a household name in Perry County and surrounding counties.

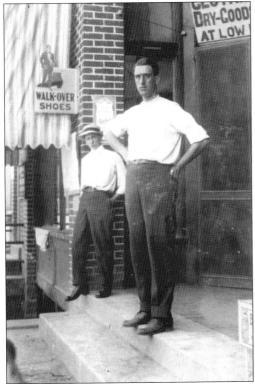

Charles Petrey and his family were well known in Hazard. In 1913, he was the secretary of the board that owned the Hazard Hardware Company. He later was the owner of the Charles E. Petrey Company.

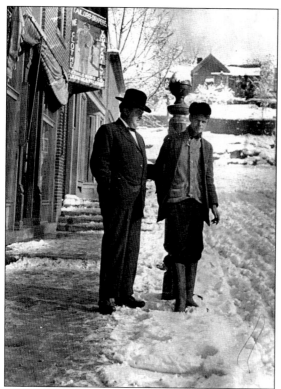

In this picture taken in the winter of 1913, Dr. Henry Maggard, a local dentist, meets Bob Cooksey on Court Street. In 2006, this location is a pedestrian walk and fountain between the Perry County Court House and the Hall of Justice. At one time, "Taxi Alley" on the other side of Main Street was named Cooksey Street after Bob Cooksey.

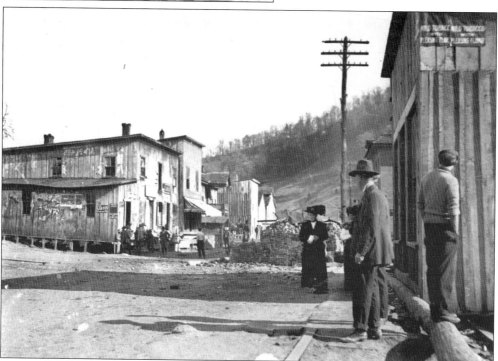

D. Y. Combs owned the buildings on the left in this 1913 photograph by John Kinner. The woman in black is Clara "Pet" Eversole. The man on the right, in the hat and suit, is Matt Cornett.

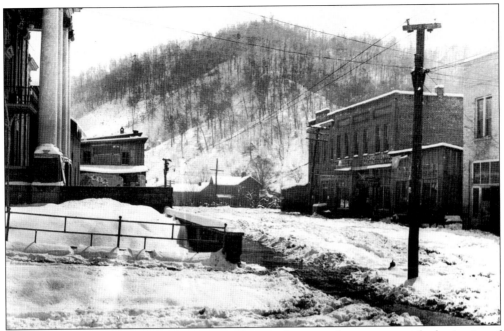

The paved sidewalk and the wall in front of the courthouse in this picture are the beginning of the improvements so needed on Main Street. The lot that was the site of the Davis Hotel is still empty after fire destroyed it December 30, 1913. The D. Y. Combs building is still evident on the corner opposite the courthouse, as it was into the 1930s.

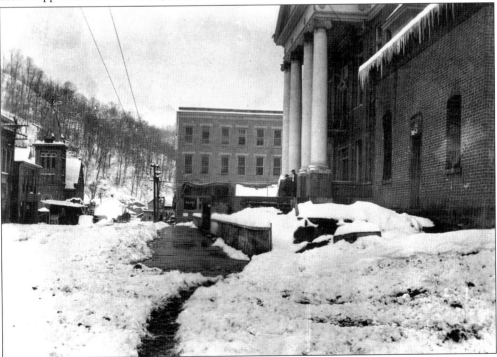

This view is in the other direction of Main Street on the same snowy day as the picture above. The jail had not yet been removed. The Beaumont Hotel is the building in the center of this picture.

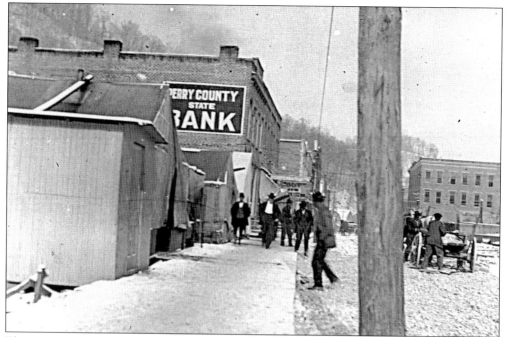

The most striking aspect of this picture is the wide sidewalk. Main Street was not completely paved until 1916. On April 11 of that year, a historic city council meeting was held that voted unanimously to pave a large area around the downtown section. In 1927, the Perry County State Bank merged with Hazard Bank and Trust Company to form the Perry Bank and Trust Company.

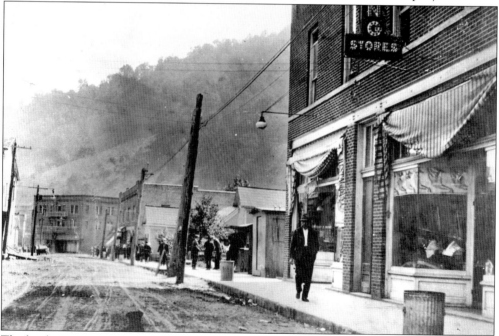

The brick structure at the end of the street is the Central Hotel. Telephone and electric wires have been installed. Long-distance calls can be made from certain locations. Main Street finally has wide sidewalks in spots, but the street, although apparently well graded, is still unpaved.

R. O. Davis was engaged in general merchandising in Hazard since 1895. At the time this picture was taken, he was preparing to erect a new building opposite the courthouse on the site of the building that had burned. Frame buildings on Main Street were slowly being replaced with brick buildings. A lot of attention was paid to a pig in this picture. A livestock pen on the north end of Main Street was constructed at one point, but mischievous boys kept opening the gate, releasing the inmates.

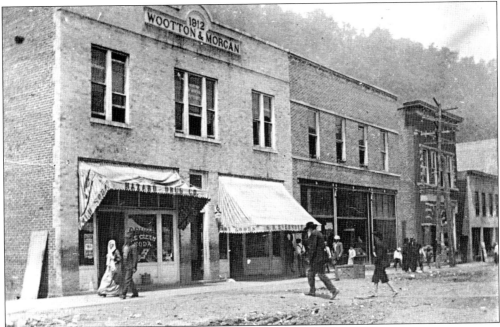

The G. B. Eversole Store, shown here with the awning lowered, was a new establishment in Hazard in 1913. Clothing for men, women, and children was ordered from Chicago, New York, and other markets. G. B. Eversole was a native of London, Kentucky. When the railroad reached Hazard, he selected the town as a promising location and a favorable place to live. The ornate building on the right is the First National Bank.

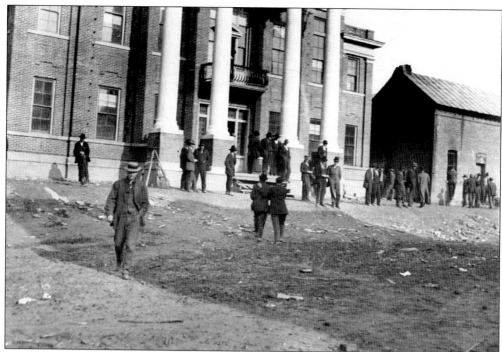

With the coming of the railroad, the progressive spirit was written up in the *Lexington Herald*. The article discussed many aspects of the developments in Hazard and Eastern Kentucky. About law and order, the article read, "The people of Perry County are fully alive to the opportunities of the great industrial development now at hand, and have worked and striven for it with all their might. There are no courts or juries anywhere who administer justice in the county tribunals with greater care."

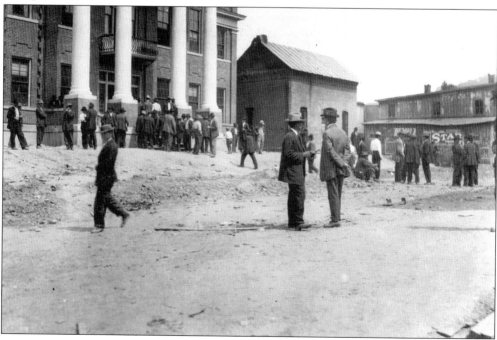

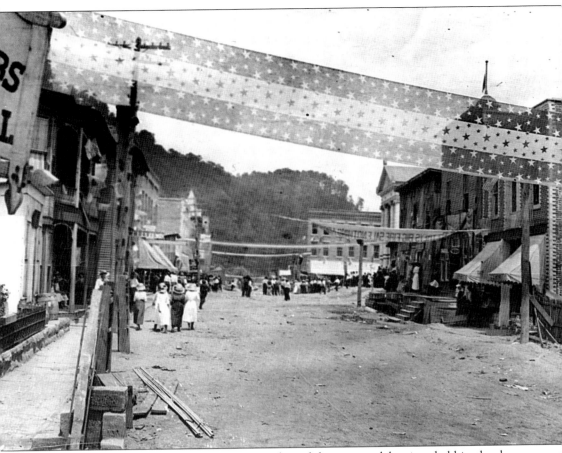

John Kinner again captures Main Street at another of the many celebrations held in the days after the coming of the railroad. Bunting with the stars and stripes in the summer might mean this date was July 4. This picture was taken before the fire that destroyed the Davis Hotel at the end of 1913.

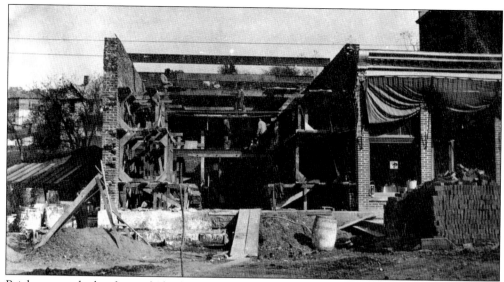

Bricks are stacked in front of Charley's Café, also shown in the picture below, for the new theater on the site. In March 1914, John Kinner and T. L. Johnson opened the Empire Theatre for moving picture shows and vaudeville with seating capacity of 251. An artist from Chicago painted the stage curtains. The building had two stories and a basement. John Kinner's studio occupied the second floor.

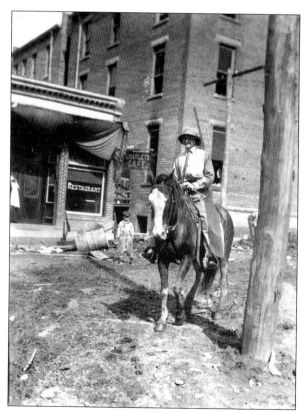

The city council requested that merchants build sidewalks. The boy in this Kinner photograph is surrounded by rubbish and mud in the street. This is Charley's Café, seen in the picture above. The rider is unidentified. The large building is the Beaumont Hotel.

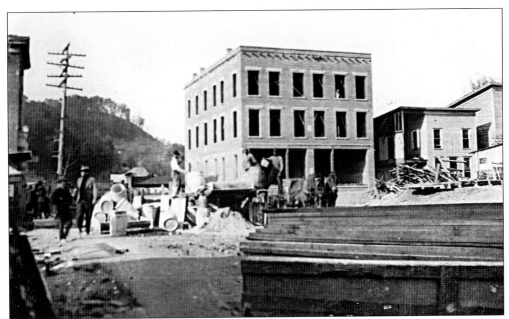

The Austin Fields Building, housing the Beaumont Hotel, was begun by early September 1912. The need for a larger hotel three months after the railroad arrived was proof of Hazard's increasing prosperity. The delivery wagon in the street could be bringing supplies for constructing the new courthouse or any of the other building projects on Main Street.

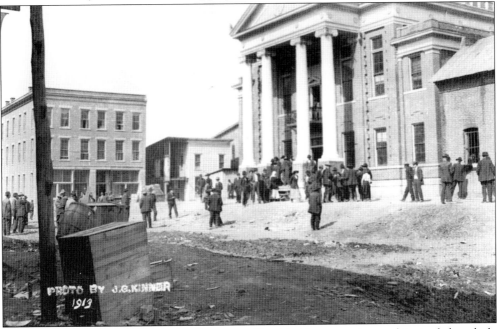

On Saturday, February 1, 1913, the Beaumont Hotel held an opening and invited the whole community to partake of a delicious meal in the dining room. The hotel was erected and equipped by Judge R. F. Fields and managed by Mr. and Mrs. George Grigsby. Hazard outgrew the Beaumont Hotel by the middle of 1913. An estimated 750 visitors came to Hazard in November 1913 alone, so by the end of the year, plans were underway for adding to the Beaumont.

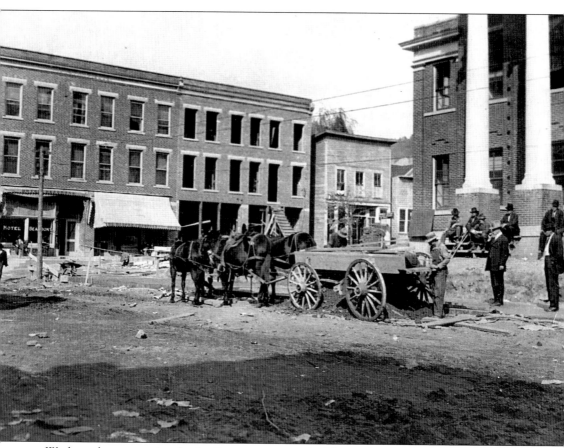

Work on the new section for the Beaumont was pushed forward as the need for rooms increased. The Beaumont Annex, which opened in February 1914, increased the number of rooms from 24 to 48. The entrance to the hotel is on the left at ground level, and the awning on the right shelters the front door for the Hazard Pharmacy.

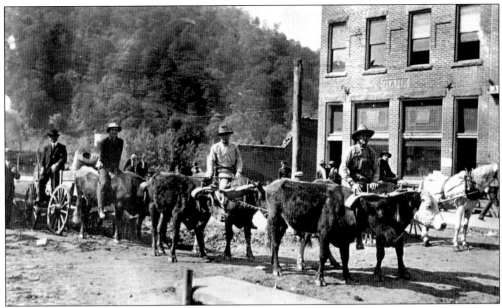

This well-known photograph, notable for its depiction of the ox team driven by John Flat Williams (the man on the last ox on the left) also shows the shell of a burned-out section of town resulting from the fire on December 30, 1913. The building on the right is the Perry County State Bank.

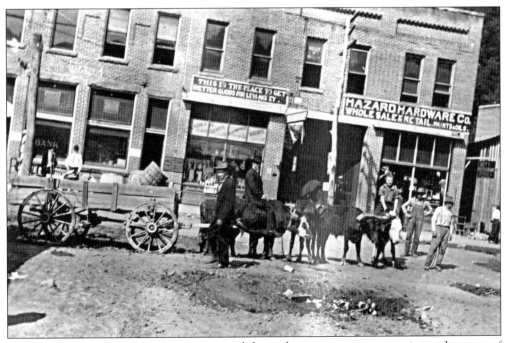

As the ox wagon in the above picture moved down the street, a young man jumped on one of the beasts of burden to get his picture taken by John Kinner. The businesses in the background, from left to right, are the Perry County State Bank, the Baltimore Store, and Hazard Hardware Company. A pole has been erected to be ready for the coming of electricity and telephones.

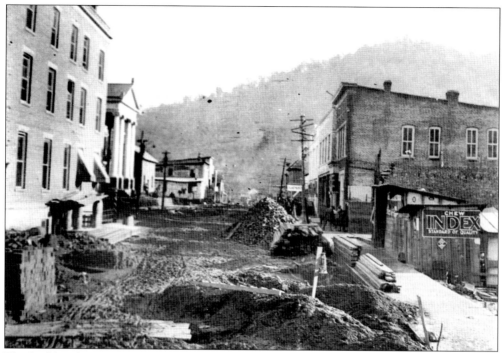

The building boom continues, but the problem of the unpaved downtown is seemingly worse in this picture. The first structure on the right is the First National Bank. The S. A. D. Jones building, next to the bank, burned on February 13, 1913.

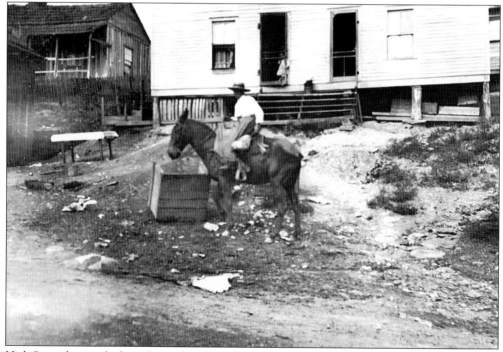

High Street does not look any better than Main Street in this picture taken by Kinner of a woman riding sidesaddle on her mule. The woman and the child at the door of the house are unidentified.

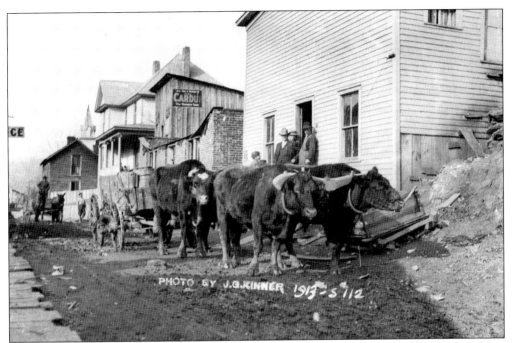

The ox team is on High Street in front of the Hazard Post Office. The church spire peeking above the buildings on the left belongs to the First Methodist Church. Kinner's subject in both of the photographs on this page is the block north of the rear of the Perry County Court House.

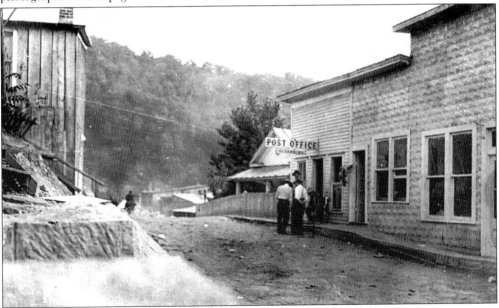

This photograph looks in the opposite direction on High Street from the one above. Until the railroad came, the mail was carried from the Jackson station on horseback. The post office in Hazard was apparently moved to High Street at the time John Kinner began taking photographs around Hazard in 1911. Refer to page 19 to see the post office on Main Street beside the First Baptist Church (burned in 1910). Horseback was still a method of mail delivery in the 1950s in some sections of Perry County.

According to the *History of Hazard Perry County* by the Daughters of the American Revolution, mail delivery in Perry County dated to 1824, when the county was three years old. Interruptions of mail delivery occurred during the Civil War. The mail has gone through continuously since. By 1910, when Hazard had a population of 537, the mail became so heavy it was impractical to carry it on a horse, so a hack was used. Carrying mail was a dangerous job. At least one carrier and his horse were killed on the route from Hazard to Hindman.

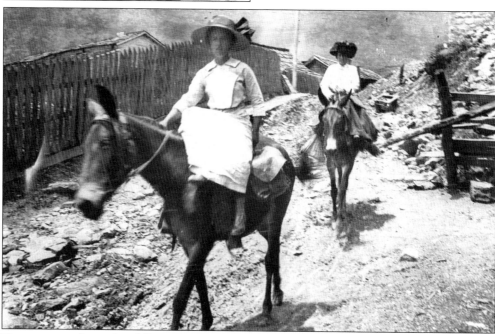

Two women riding sidesaddle on High Street could be heading for the post office to get their mail. Hazard did not have home delivery of mail until much later. Of course, the riders might have had any number of purposes for traveling on the streets of Hazard. We are fortunate that they found themselves in John Kinner's lenses that day.

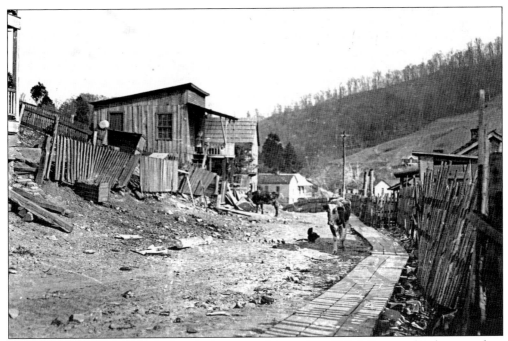

It is not evident in this picture, but the houses in this section of High Street were close together. On April 2, 1915, a fire started on the second floor in the house of Malen Standifer. The Standifer house is not shown in this picture. The frame house with the front porch belongs to "Red" Bob Combs.

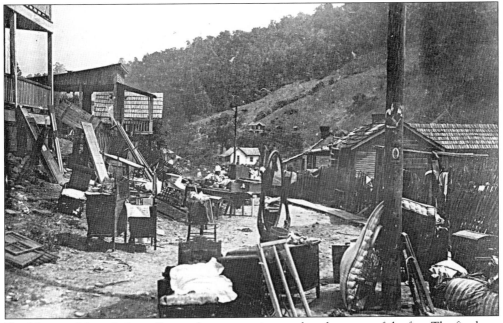

Neighbors and friends from all over the community raced to the scene of the fire. The fire hose was brought out, but the pump to the water tower was in disrepair. A bucket brigade hurriedly tried to fight the fire to keep it from spreading. Furniture from houses all up and down High Street was carried outside to the street.

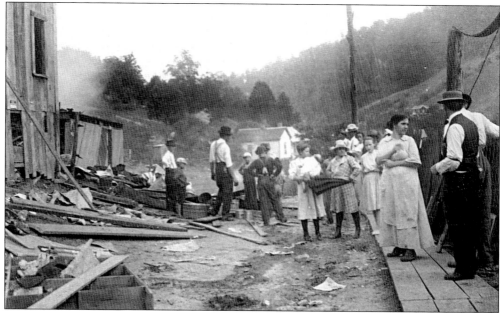

This account of the fire comes from the *Hazard Herald*: "The heat was so intense, and the conditions on the hillside so disadvantageous, that . . . efforts were unsuccessful, and both [the D. Y. Combses' house and the D. B. Sallys' house] were quickly ablaze, whence the flames leaped on at once into the two other buildings owned by Malen Standifer and that of Lacy Combs, standing further up on the hillside. All went almost like a flash of gunpowder, as the fire was over in forty minutes."

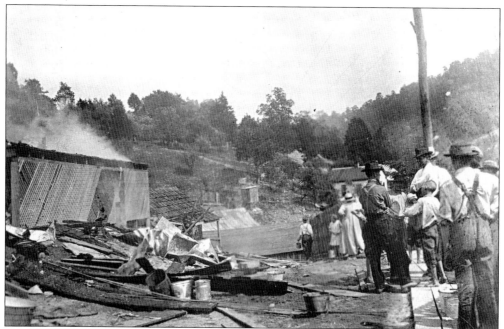

The *Hazard Herald* also stated, "Fire caught the Hazard Grocery Company building, thirty feet across from the Ben Sally house. Those on the roof tore the metal sheathing loose, and got water to the blaze. . . . Men and women ran like mad, bringing water." Six houses burned to the ground.

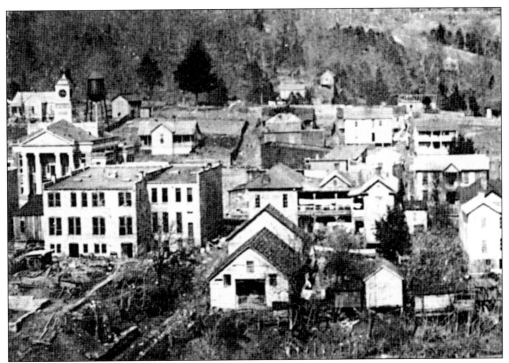

This photograph of the Davis Hotel was shot from across the river. It burned in December 1913. The houses that burned in the fires on page 85 and 86 are in the background.

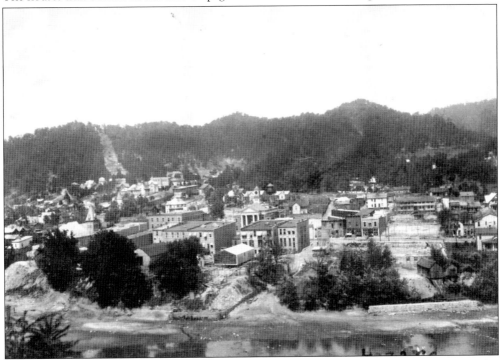

Kinner took this picture after the Davis Hotel had burned. The new Hazard Graded School is in view in the Backwoods in the left background.

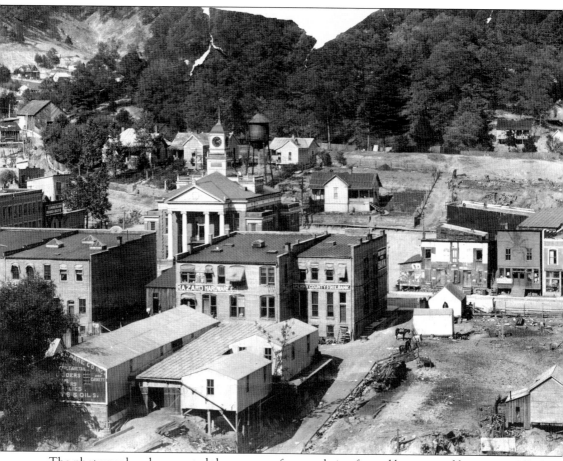

The photographer documented the process of a town being formed by man and by nature. All of the buildings on the upper side of High Street were wiped out by the fire that occurred on April 2, 1915. In this shot, no people are evident at 3:10 on a hot summer afternoon.

Six

MINING COAL

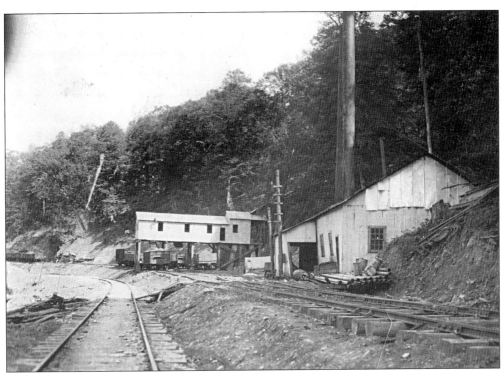

The Hazard Coal Company was the third mine to ship coal by rail to outside markets. The two main organizers were John Gorman and W. G. Polk, who leased land from Mr. and Mrs. J. L. Johnson and Mr. and Mrs. J. E. Johnson Sr., starting April 29, 1913. Perry Gorman was the superintendent of the Hazard Coal Company mine. This operation, located across the river from the east end of Hazard, was the first electrically operated mine in the Hazard field and the first mine to ship uniform sizes of coal.

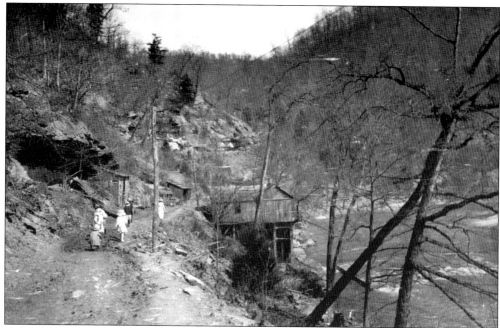

Lothair became an important station on the railroad because of the Kentucky Jewell Coal Company. Another tunnel was constructed south of Hazard for the tracks to reach Lothair. On a nice summer day, it was a good walk to Lothair along the road shown in this photograph by Kinner. The road went along one large bend in the river. After the coming of the railroad, the walk through the tunnel south of Hazard was shorter but more precarious.

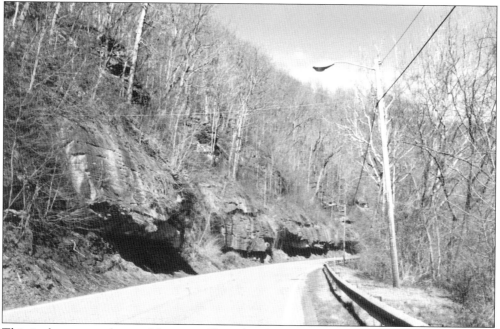

This is the present-day road between Hazard and Lothair. The photograph shows that the overhangs in the 1913 pictures are almost the same today. The one perceivable difference is the higher roadbed.

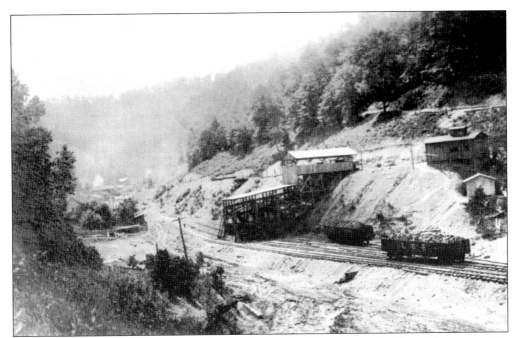

The Hazard-Dean Coal Company operated in the number four seam and had a maximum capacity of 1,000 tons daily output. It started shipping in May 1914. Investments from Tennessee provided operating capital. Several years later, this operation combined with the Hazard Coal Company and became the Hazard–Blue Grass Coal Company under the operation of J. E. Johnson Sr.

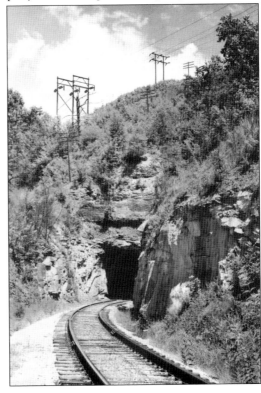

The Hazard-Lothair tunnel entrance seen here is across the river from East Main Street behind the old Town House Motel. This tunnel was built by the end of 1912, after the railroad construction moved on past Hazard.

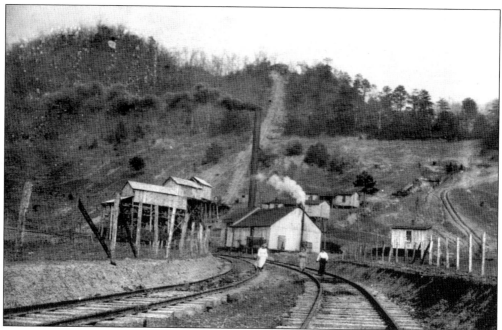

The Kentucky Jewell Coal Company in Lothair was about a mile south of Hazard in Lothair and operated by electricity from its first installation, using power from the East Tennessee Coal Company in Glomawr, three miles away. Kentucky Jewell began to ship coal on October 3, 1913. In 1917, this mine was sold and was renamed Algoma Block Coal Company.

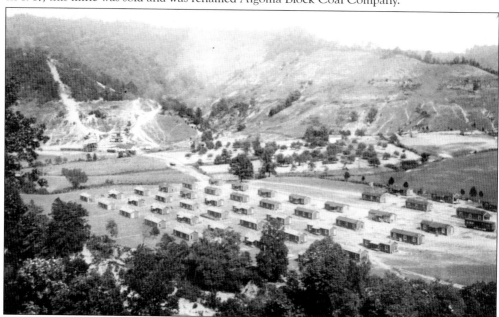

The Kentucky Jewell coal tipple is in the left background. On April 1, 1915, Mr. Harry Bullock, in charge of loading, decided for a stunt to hold up a shipment of coal on the exceptionally long storage track until there was a full trainload—about 30 cars—and then he had them to pull out all at the same time. The coal camp with houses in neat rows is in the foreground. The layout of the camp shaped the future streets of Lothair.

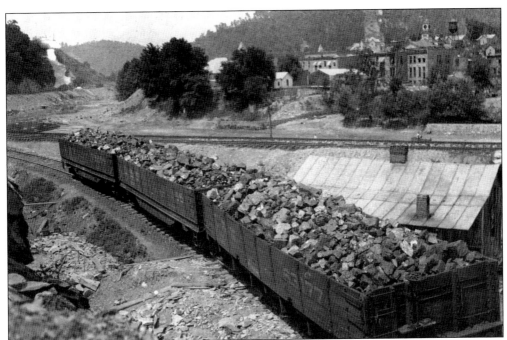

Coal cars rolling out of the Hazard Coal Company wait to be attached to a coal train headed out of Hazard. The gondola cars in this picture are owned by the Lexington and Eastern Railway Company.

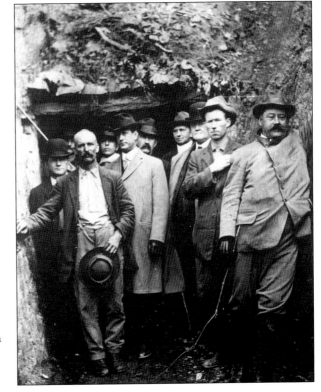

John Kinner identified these men as a party of coal and railroad men in Hazard in 1913. The man in the center in the light overcoat is Mr. G. H. Justice, division engineer, who supervised survey and construction of the railroad from Quicksand to McRoberts. The man wearing the derby hat on the left is John C. C. Mayo, widely recognized coal developer who died in May 1914.

Blue Diamond Coal Company opened the first operation on First Creek in Perry County in 1915. Coal production began in 1916. The first tipple, which served the mining operation for 35 to 40 years, was constructed of sawed oak and beech timbers from trees cut down in the vicinity of the mine. In time, it was replaced with a steel tipple. In the peak production years, the company loaded 100 railroad cars in a day. These two photographs of the Blue Diamond tram trestle over Lost Creek are from the Lawrence O. Davis collection.

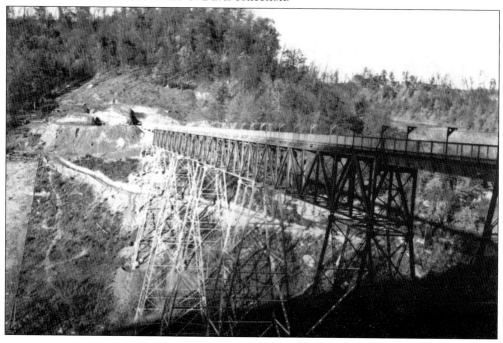

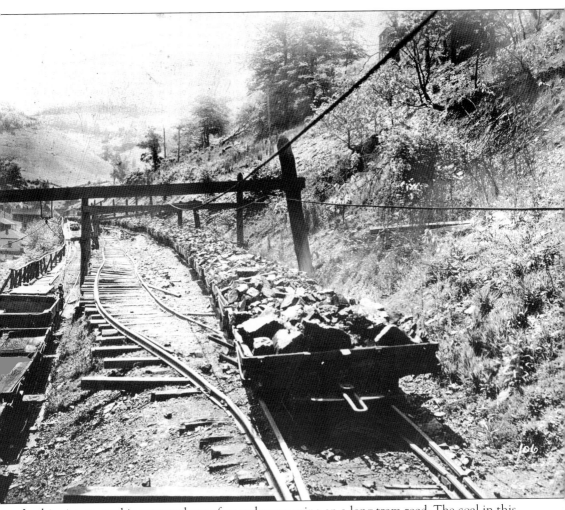

In this picture, coal is conveyed out of an unknown mine on a long tram road. The coal in this picture has recently been dug and is exiting the mine. At the tipple, the coal will be screened and divided into uniform sizes and loaded onto gondolas or "gons" to be transported to coal yards, manufacturing plants, or destinations where electricity is produced.

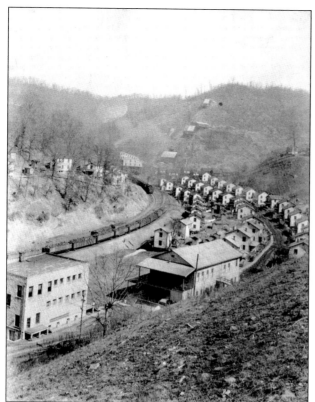

These two photographs were taken from opposite ends of the coal camp of Hardburly. When Hardy-Burlingham Coal Company commenced to mine coal in 1917, the company provided free electricity to camp houses. They had their own store, hospital, doctor's office, dentist, dry cleaning, water, baseball field, and tennis courts. The houses got fresh paint every two or three years. The work force was around 487. The mine ceased operation in 1948.

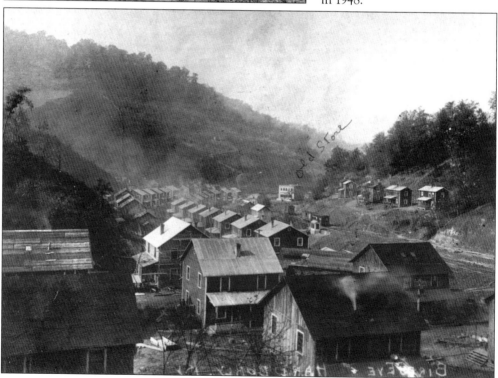

Seven

HAZARD YARDS

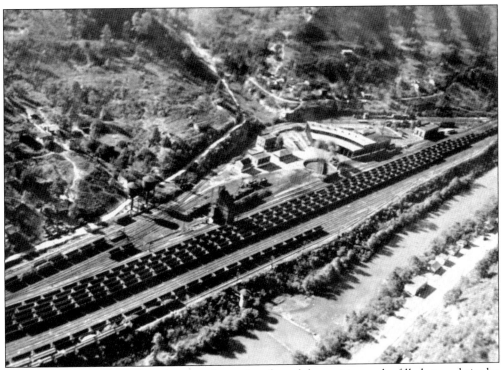

The Hazard Yards, c. 1945, is the stage for ranks of gondolas waiting to be filled at coal tipples throughout the region. Coal by the hundreds of thousands of tons went out each week, bound for coal yards, manufacturing plants, or electric power plants. The North Fork of the Kentucky River and Highway 15 may be seen in the foreground.

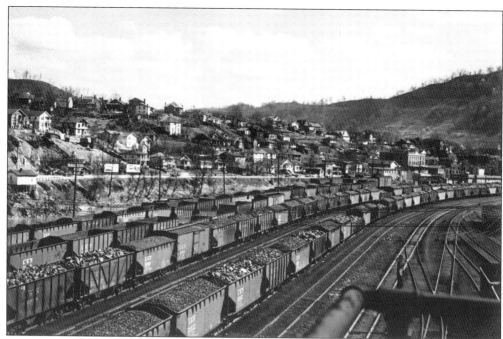

This classic photograph of the Hazard Yards, c. 1945, also presents an exceptional panorama of the north end of Hazard. The ridge in the background is Eversole Street. Highway 15 is highly visible threading through the center ground. The cars in the foreground are transporting coal in uniform sizes.

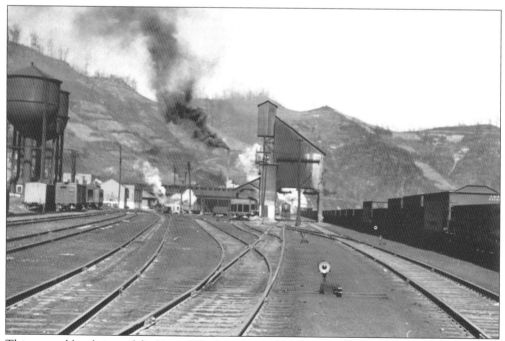

This ground-level view of the Hazard Yards in the mid-1940s was taken before diesel engines were being used, and engines got water from towers on the left. The absence of trees on the mountains around Hazard is a noticeable aspect of this picture.

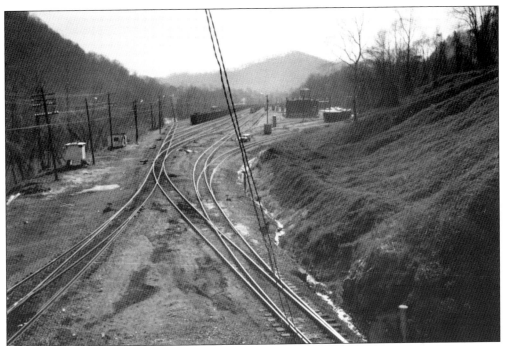

This picture by Jim Strong, taken in 1993, recaptures the approach to the Hazard Yards from the top of the mountain using the same perspective as the photographs that John Kinner took in 1912 (see page 38).

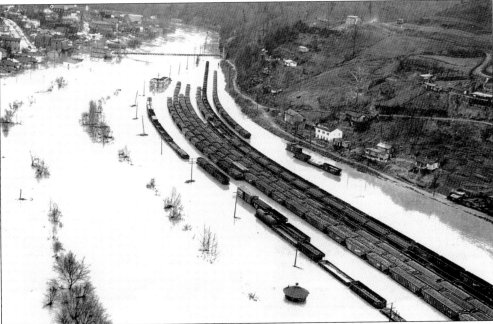

Coal "gons" wait helplessly in the Hazard Yards during the 1963 flood. The swinging bridge at the top of the picture is over the water, but the access to the bridge is covered. The railroad bore tremendous track damage during this flood. The street on the left is the old bypass that was opened in the early 1950s.

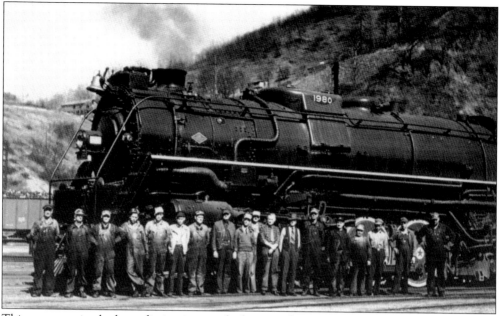

This steam engine had two distinctions in the history of L&N: It was the last new steam engine they purchased, and it was the largest of all steam engines they ever used. It was built by LIMA Locomotive Works in Lima, Ohio. In Perry County, it was serviced in the Dent Yard at the mouth of Leatherwood. The Hazard shop was not big enough to accommodate the size of the engine. John Robertson was one Hazard mechanic who worked on the engine.

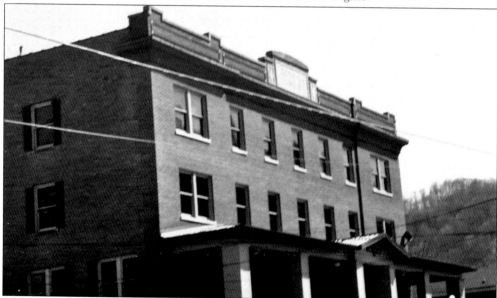

A current picture of the YMCA located on the north end of Main Street reflects the same greatness of the building from the time it was dedicated in 1923. The L&N constructed it for transitory railroad workers to use as a hotel. The structure is built of steel, brick, and tile, with concrete floors throughout. The first floor consisted of an assembly room, a dining room, and the best kitchen of the time. The upper floors contained large and airy sleeping rooms. Showers and washrooms were in the basement.

Eight

SCENES AROUND HAZARD

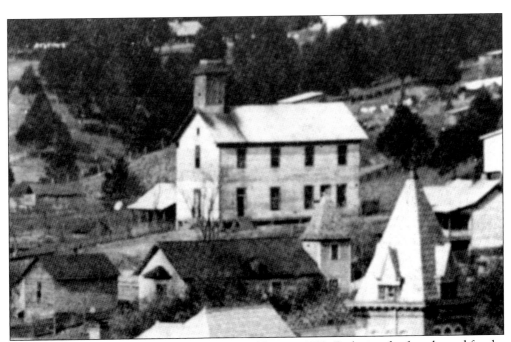

W. O. Davis began building the school pictured here in 1893. Each time he found wood for the school, it was appropriated for another purpose. The third time was the charm, and he built a one-story school with wood he got from a raft floating down the river. Realizing that a better school was needed, in 1894, the second story was added. Late in 1912, the building was condemned. The 1913–1914 school year was difficult, as students had to move from place to place while the new school on Broadway neared completion. The new Hazard Graded School was dedicated September 7, 1914. The steeple in the foreground belongs to the First Baptist Church, and the First Presbyterian Church is the building with a low, square steeple.

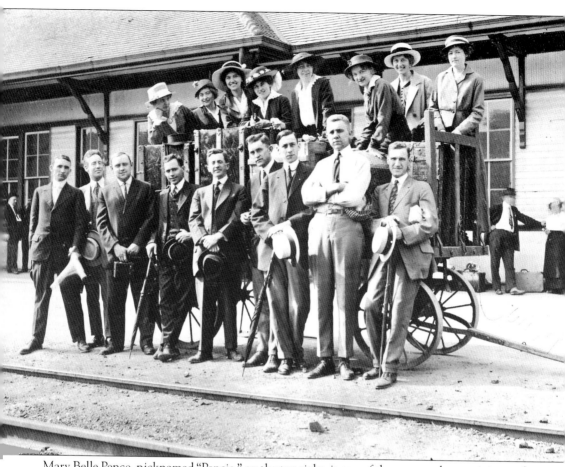

Mary Belle Pence, nicknamed "Pencie," on the top right, is one of the new teachers arriving at the Hazard Depot in the fall of 1914. The gentleman on the right is George Wolfe. After the Hazard Graded School was opened, the school board hired teachers from other locations in Kentucky. Some of the young women, like Effie Duke, stayed in Hazard, married, and lived here the rest of their lives. The teachers lived together in a house on Broadway. They named their cottage the "Twilldo" because they said, "It's not much, but 'twill do."

G. C. Gilmore, principal of the Hazard Graded School, is seen here as he walks along the tracks on the Jewell Ridge Bridge, otherwise known as the Lothair Tunnel. He was a graduate of the Eastern Kentucky State Normal School.

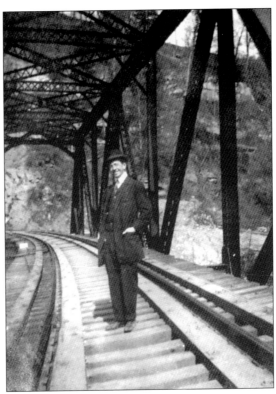

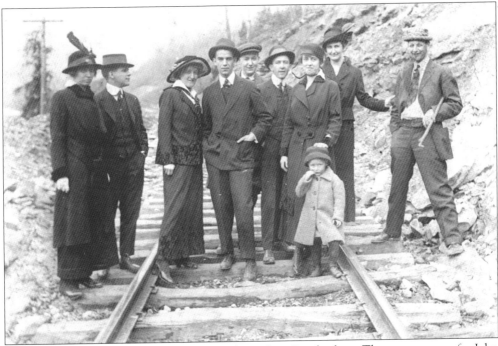

Here we see another group walking the tracks in their Sunday best. They stop to pose for John Kinner. The gentleman in the middle with his hand in his pocket is G. C. Gilmore (see picture above). No one else in this group has been identified.

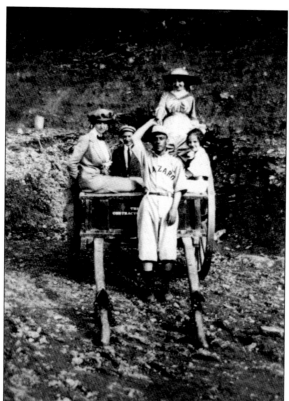

"Tallow" Dick Combs brought a baseball and a rule book home with him after a trip to Pittsburgh. The first baseball game in Hazard was played in 1889 between Hazard and Hindman on an open field on Broadway. The score was Hazard 13, Hindman 6. Here an unidentified member of the Hazard team poses for Kinner after a game with Jackson. Kinner identified Carrie Watts on the wagon seat. The other young people are unidentified.

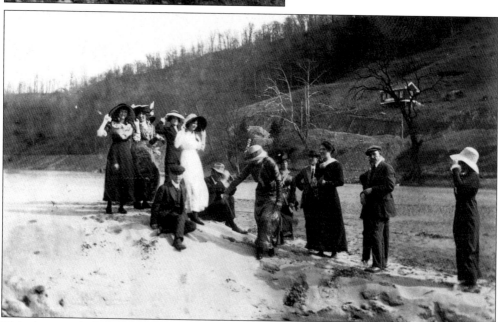

This photograph shows an example of an impromptu outing by the river in Hazard. Clara Collins, who was later Mrs. Bailey Wootton, described in her book *They Have Topped the Mountain*, "If someone suggested a walk, the whole crowd fell in and took a walk. If somebody wanted to dance they made it unanimous. . . . I know it was one of the happiest times in my life."

These unidentified young people are enjoying each other's company while walking the ties somewhere around Hazard. Railroad tracks provided various types of entertainment, as we see in several of John Kinner's pictures.

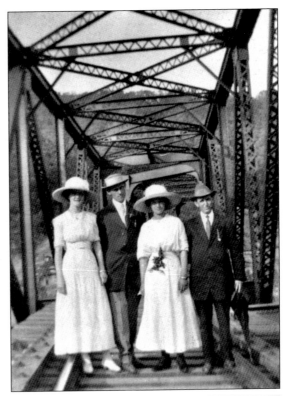

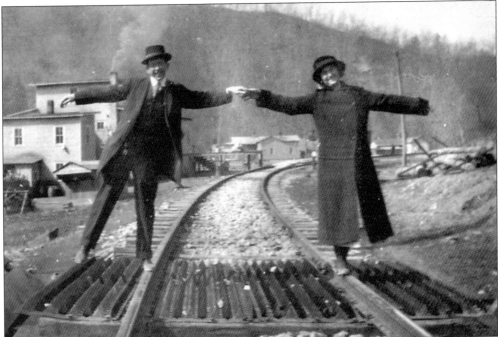

Allie Hendren and her unidentified friend spent this winter afternoon "walking the ties." Fortunately they met John Kinner with his camera as he was covering his territory. They are in Lothair in the picture, and that means they have quite a hike to get back to Hazard.

Starting in 1914, Hazard City primary and secondary students as well as Perry County secondary students attended school in the Hazard Graded School. The street going downhill from the right foreground is Rockaway Street. In 2006, the school is used as the Hazard City Independent Schools Administration Building.

Many fine Victorian houses graced Broadway in the early 20th century, as seen through John Kinner's camera. Lines carried electricity to these houses. There was an auditorium on the second floor of the Hazard Graded School. Fewer windows on the side of the school in this picture indicate the back of the stage.

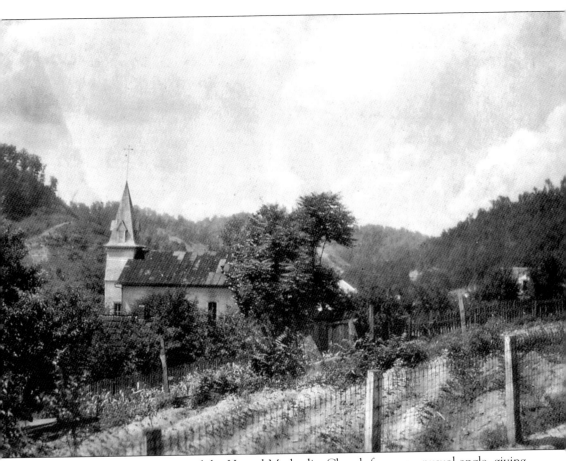

John Kinner took this picture of the Hazard Methodist Church from an unusual angle, giving the impression that the church is in a rural setting; it actually faced High Street. Refer to the picture on page 115 to see the placement of the steeple from another perspective. This church was organized in 1887 and had its first full-time minister in 1909; Rev. Walter V. Cropper served from 1909 to 1913. Near the end of this time, the congregation, under his leadership, tore down this old church and replaced it with the new structure along with a house for the minister. Charles Bowman donated a large sum to the building fund, so in his honor, the church was named the Bowman Memorial Methodist Church.

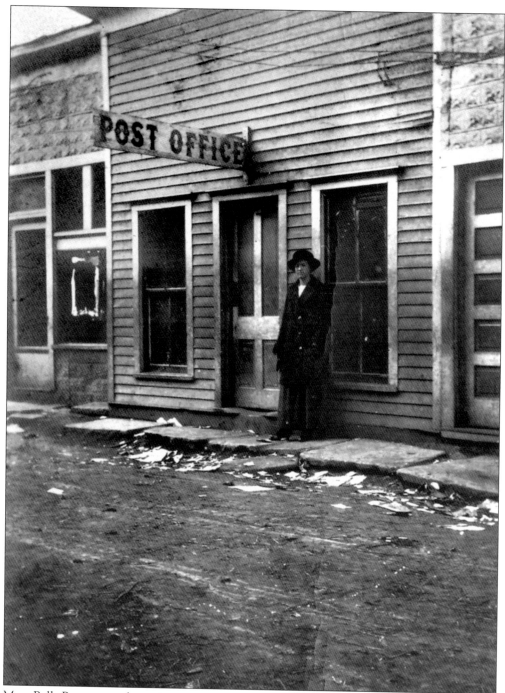

Mary Belle Pence, a teacher at Hazard Graded School, waits in front of the Hazard Post Office on High Street for the incoming mail. Miss Pence lived with other teachers in the Twilldo cottage on Broadway. She earned her teaching degree at the State University of Kentucky. For four years, she played on the women's Kentucky championship basketball team.

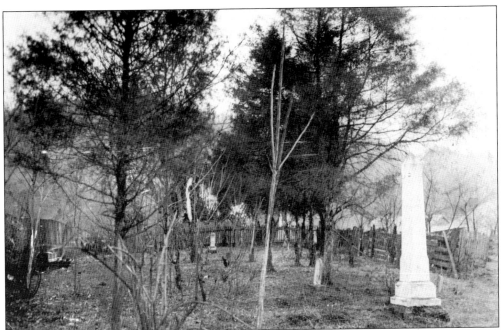

This graveyard is still located on Broadway across from the First Presbyterian Church. The obelisk marks the grave of John E. Campbell, who was killed in 1888 during the French and Eversole feud. He lost his life because he could not give the password as he came into town. He was shot in the leg and died of blood poisoning.

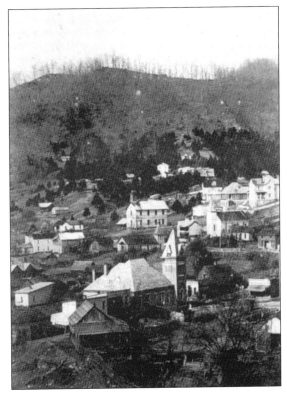

Kinner's photograph shot from across the river captures the four steeples. At upper left is the two-story school that the town condemned in 1913. The Methodist church is directly to the right of the school. The First Baptist Church is the largest and is in the foreground. The Presbyterian church can be seen between the school and the Baptist church. The Backwoods section, lush with cedar trees, overlooks the rest of town.

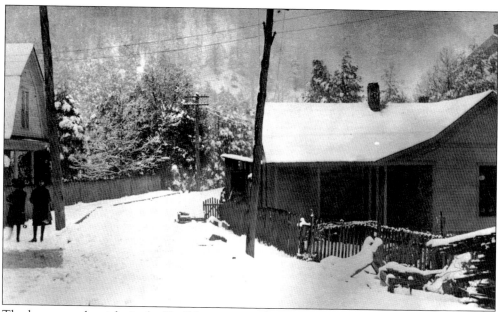

The house on the right is the Twilldo cottage, where all the teachers at the Hazard Graded School lived together. The two children on the sidewalk are Lucille and Ruth Farrel Kinner. They attended HBI, which was farther up Broadway from the teachers' cottage. Many people who grew up in Hazard went to HBI after it was purchased by the Hazard Board of Education. (The Hazard Graded School building was called "Lower Broadway" and the HBI building was referred to as "Upper Broadway.")

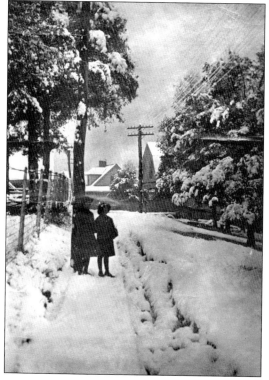

By 1913, there were several fine houses on Broadway. John Kinner took this picture of his two daughters, Lucille (left) and Ruth Farrel, as they were walking up Broadway toward HBI.

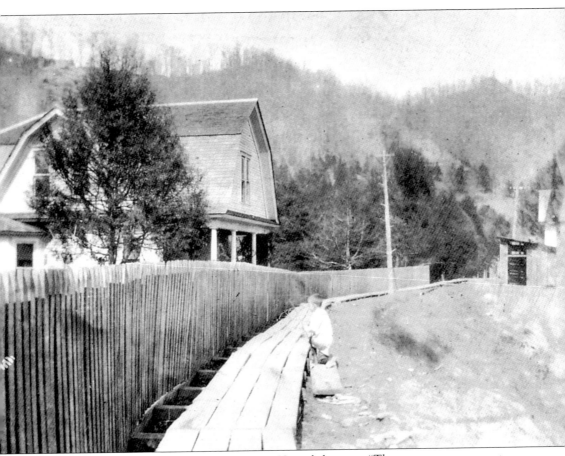

Clara Collins Wootton described the streets in Hazard this way: "There were no pavements or sidewalks, except irregular stretches of boardwalk laid by the property owners." This section of Broadway across from the Twilldo teachers' cottage illustrates the state of sidewalks around town. Children used boardwalks for playing hide and seek.

In the late summer of 1912, a large spread appeared in the *Hazard Herald* promoting lots for sale in the subdivision named Cedar Crag. The advertisement depicted a delightful locality in the trees of the Backwoods that was cool in the summer months.

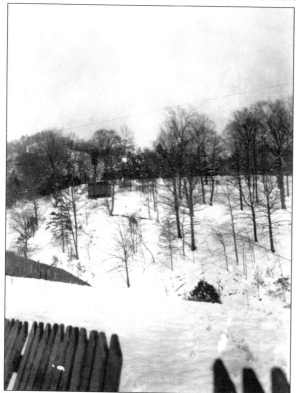

James B. Hoge, an attorney from Washington, D.C., who came to Hazard to manage the office of the Kentucky River Coal Corporation, was the first to purchase land in the Cedar Crag subdivision. He bought several lots on the highest point with enough property to make spacious grounds covered by large, handsome oak trees. Hoge has the distinction of naming Oak Street.

A narrow valley shaped by Town Branch divided Hazard into two sections. With great difficulty, Cedar Crag was accessed by walking down on one side and climbing up the other. In the newspaper on August 12, 1912, the promoters promised "a good substantial wagon bridge" would be built across the ravine, putting residents of the Backwoods within two or three minutes of the business section. They made good on the promise, and this bridge was used until it was dismantled in the early 1990s.

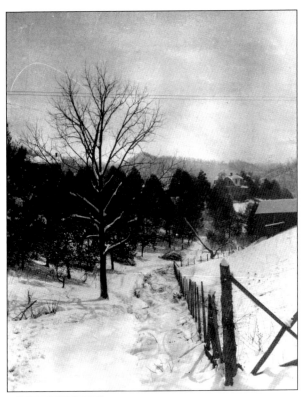

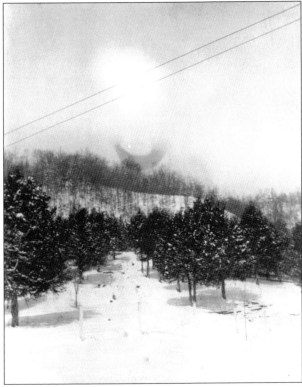

The developers for Cedar Crag marketed the section as the "hunting ground of the Red Man" and the "prehistoric home of the Mound Builder." The *Hazard Herald* endorsed this section as the best place to live in town, convenient to good schools, close to churches, affordable, and in a natural forest where children can live in healthful surroundings.

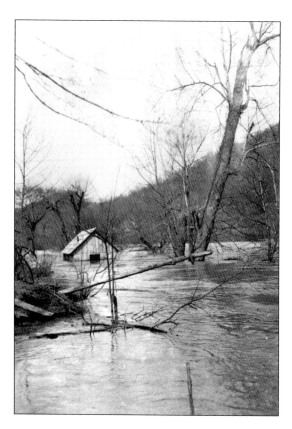

The disastrous flood of 1913 is not mentioned often in Perry County history. Hundreds of thousands of people were killed or rendered homeless from widespread flooding, not just in Kentucky but also throughout the country. Telephone and telegraph lines were down and landslides and high waters washed out railroad tracks, so from March 24 to March 31, Hazard was completely cut off from the rest of the world.

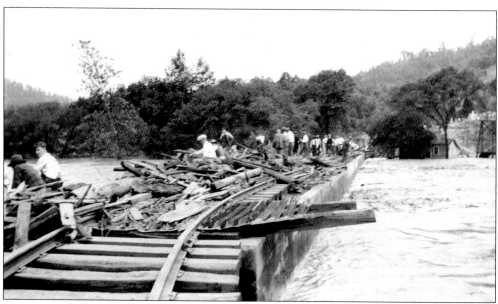

The flood of 1927 covered the railroad bridge at Lothair with wreckage. The powerful flash flood took out more than one bridge on the river. In 2006, this bridge is still used. It crosses over the North Fork of the Kentucky River beside the greens of the Hazard Golf Course.

Nine

THROUGH THE YEARS

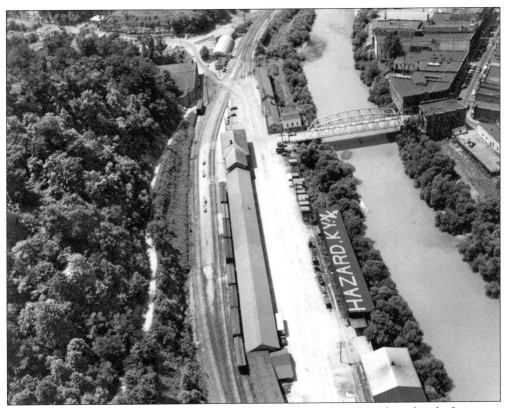

This is an aerial photograph of the depot section around the Penny Bridge taken by Lawrence Davis. The name of the town and directional symbol pointing to the airport was painted on the roof of Home Lumber Company for airplane pilots. At the time of this picture, the railroad station still had a long platform for loading passengers. The road to the left in the upper corner is Bluegrass Hollow.

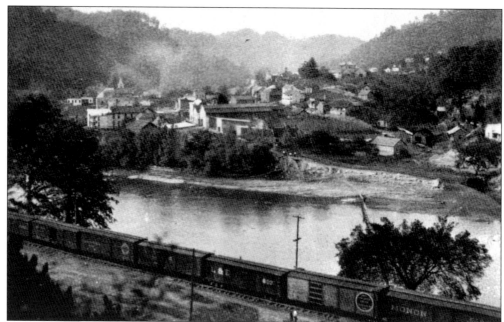

The empty lot just up the bank from the walking bridge (see page 39) was the site of the earliest structure in Hazard built by Elijah Combs, the first settler. He arrived in 1795 and established Hazard. His "Old Log Fort," built around 1796, was a 40-by-60-foot cabin with a tavern and family quarters on the first floor and an inn upstairs. The town trustees held court in Elijah's tavern until they built a courthouse in 1836. Elijah's inn stood for 104 years.

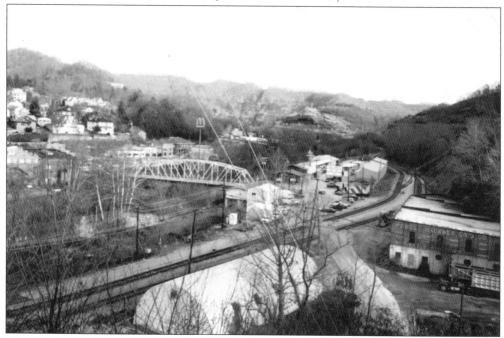

This is how the section around the Penny Bridge appeared in 1993. McDonald's had arrived. Home Lumber Company used taller storage sheds and opened a paint store. The city of Hazard had a brand-new fire department.

During World War II, in a well-publicized scrap drive, huge piles of metal in all shapes and forms were gathered from all over Perry County and brought to Main Street. It was hauled to the railroad station in volunteers' pick-up trucks. The railroad transported the scrap to Cincinnati, where it was dispersed to manufacturing plants and melted down to build guns and tanks.

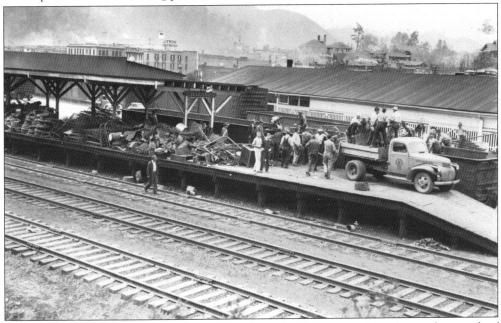

The Perry County Civil Defense Council decided to hold the scrap drive during the month of June 1943. Stores were closed one day a week to give everyone an opportunity to participate. Ira Spencer, from Brown's Fork, brought a sled load of scrap pulled by a mule. The senior class of Hazard High School only had nine young men who had not been called to serve in the army.

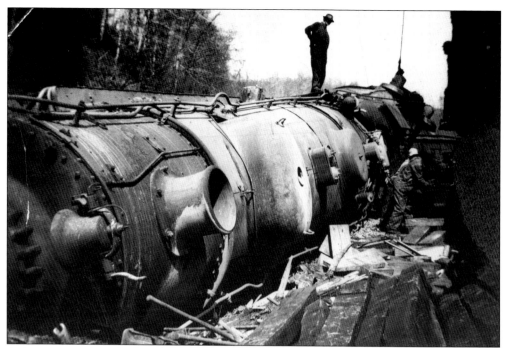

Sadness spread through the community with this tragedy that occurred on March 17, 1948. Two trainmen—Warren G. Reynolds, a 26-year-old brakeman, and Carl Mays, a fireman—lost their lives in this shocking train derailment. Rail transportation had a reputation as a very safe mode of travel and commerce. The pictures came from the family of Miller Cornett, the train engineer.

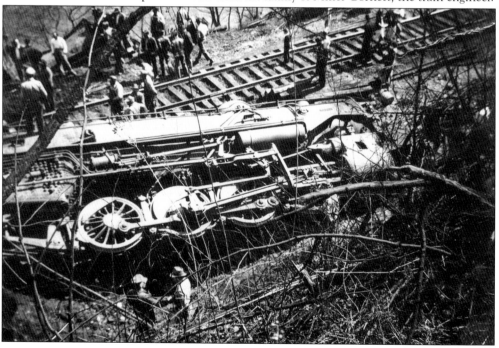

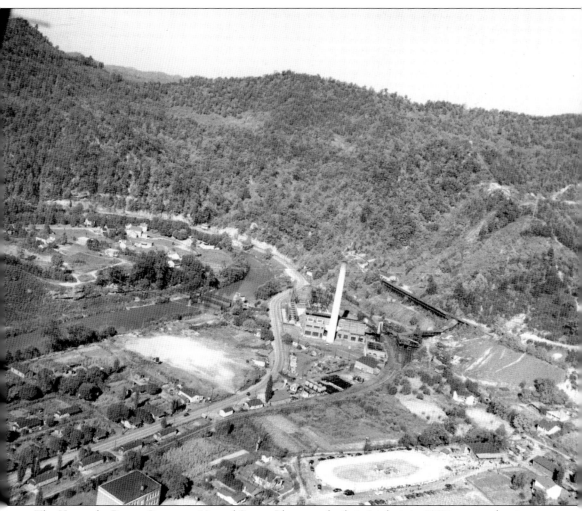

The Kentucky Power Company Hazard Steam Plant was built in Lothair in 1917, next to the site of the Algoma Coal Company. The plant's main function was to serve rapidly expanding coal operations. Algoma had a conveyor belt running directly to the power plant. The 250-foot stack was built in 1927, replacing four smaller metal stacks. The stack was felled in October 1958, when the plant in this picture was retired.

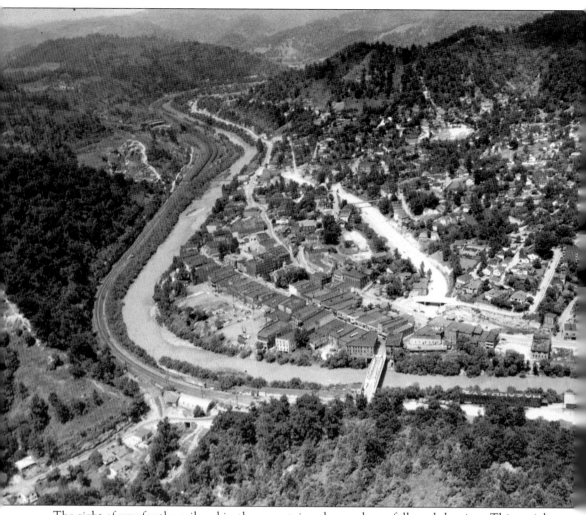

The right-of-way for the railroad in the mountains almost always followed the river. This aerial photograph by L. O. Davis, taken after 1950, depicts the railroad and the river in their parallel course through the narrow valley of the North Fork of the Kentucky River.

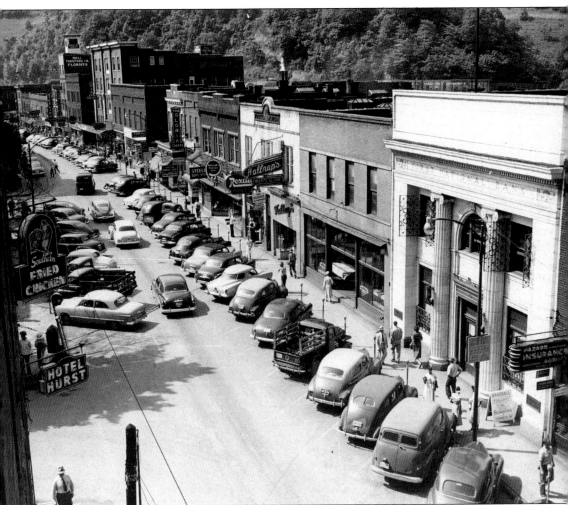

Main Street in Hazard was so congested in the 1940s and 1950s that it was often difficult to find a parking place on the street in front of the stores. Passenger trains were still pulling in and out of Hazard on schedule. Shopping trips to Lexington took some commerce out of town until the last passenger train in 1956. In the 1970s, Main Street began having to share business with the new strip mall, called the Grand Vue Plaza, a few miles out of town.

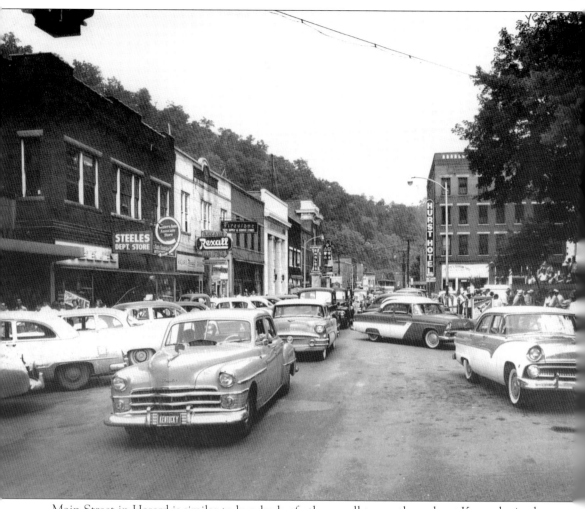

Main Street in Hazard is similar to hundreds of other small towns throughout Kentucky in the mid-1940s. Rexall Drug in the Wootton Morgan building was a popular hangout after school for boys and girls from Hazard High School. The white building is the Peoples Bank.

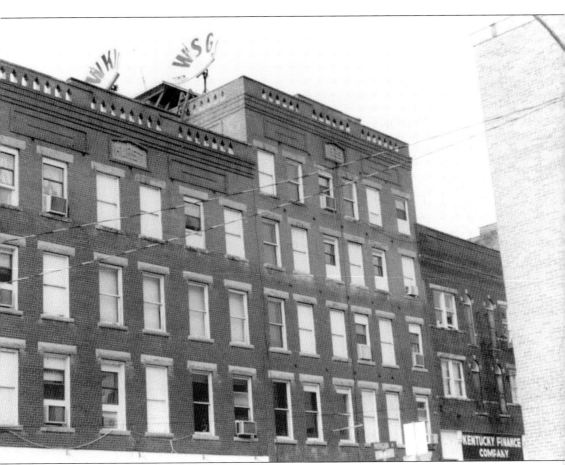

Another story was added to the original Austin Fields Building that is pictured on page 79. This picture, taken in 1986, shows most of the building except the street level. This was the home of WKIC-WSGS Radio before it was torn down in 2001 to make way for the Hall of Justice.

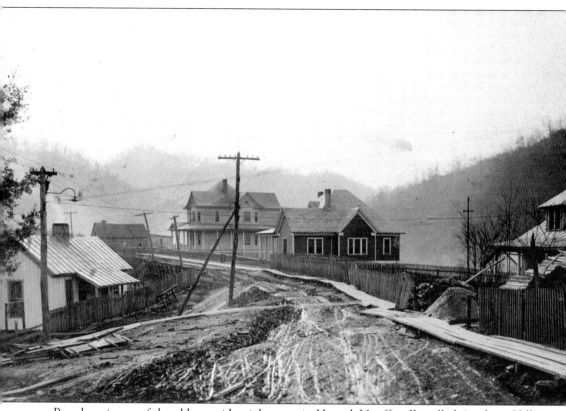

Broadway is one of the oldest residential streets in Hazard. Unofficially called Academy Hill, it became even more desirable with the construction of Hazard Baptist Institute. This wintry scene tells the story of how difficult a problem the mud was in the early days of the 20th century.

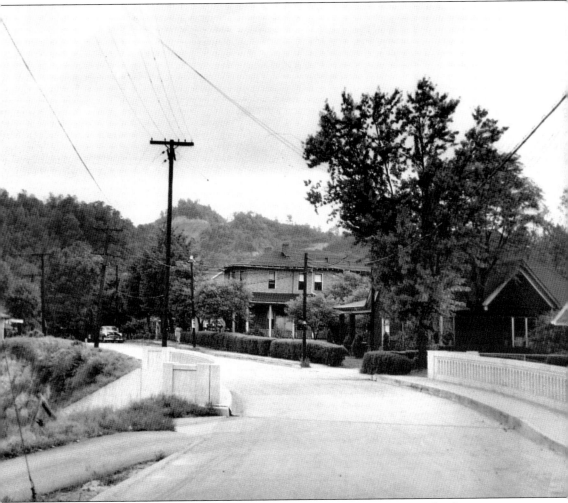

The look of Broadway changed when the bypass was built in 1950. Excavation for the new street cutting through Broadway meant some of the houses had to be moved. This picture was taken from the same angle as Kinner's on page 124, showing that the overpass has been built. The street continues today as one of the extremely attractive residential streets in Hazard, as it was in the early days around the turn of the 20th century.

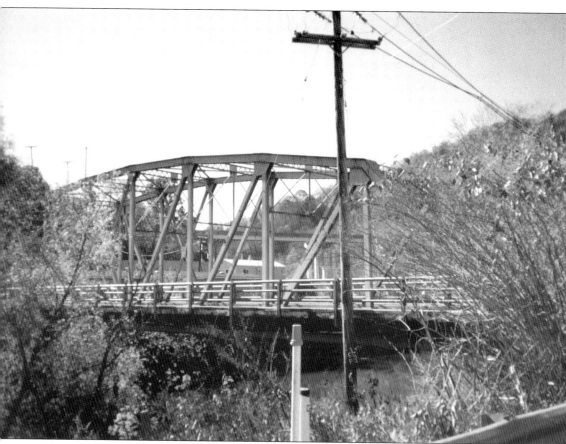

This picture of the Penny Bridge was snapped in 2005 from the McDonald's parking lot. A capped gas well stands in the foreground. At one time, the Central Hotel was at this location (see page 74) and used this well for lighting, heating, and cooking. This is the bridge that replaced the one lost in the 1927 flood.

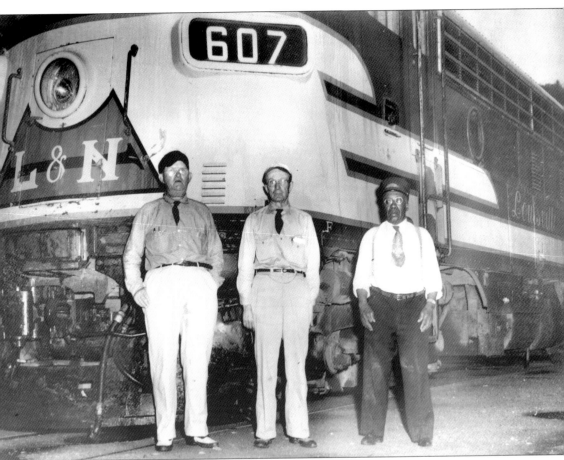

This is the engine on the last passenger train. John Palmer, engineer, is on the left, and "Ruby" Mefford, fireman, is center. The conductor on the right is unidentified. At 6:55 a.m. on June 15, 1956, the final passenger train departed the Hazard station bound for Lexington on the last run after 44 years. The course of the train at times hugged close to the mountainside as it snaked along the winding course that paralleled the North Fork of the Kentucky River, crossing and re-crossing streams, going through tunnels, and occasionally catching a glimpse of the highway. At midday, No. 4 rolled into Union Station, the end of the line and the end of passenger train travel out of Eastern Kentucky.

ACROSS AMERICA, PEOPLE ARE DISCOVERING SOMETHING WONDERFUL. *THEIR HERITAGE.*

Arcadia Publishing is the leading local history publisher in the United States. With more than 3,000 titles in print and hundreds of new titles released every year, Arcadia has extensive specialized experience chronicling the history of communities and celebrating America's hidden stories, bringing to life the people, places, and events from the past. To discover the history of other communities across the nation, please visit:

www.arcadiapublishing.com

Customized search tools allow you to find regional history books about the town where you grew up, the cities where your friends and family live, the town where your parents met, or even that retirement spot you've been dreaming about.